WHAT ELSE IS IN THE TEACHES OF PEACHES

By Peaches
Photographs by Holger Talinski

Published by Akashic Books
©2015 Peaches
Photographs ©2015 Holger Talinski
Design and layout by Christina Taphorn

ISBN: 978-1-61775-357-2
Library of Congress Control Number: 2014955095
Printed in Singapore
First printing

Akashic Books
Twitter: @AkashicBooks
Facebook: AkashicBooks
www.akashicbooks.com

To my sister Suri,
now you have visuals to go with all my stories
PEACHES

To the girl
I am looking forward to growing old with, Isabell
HOLGER

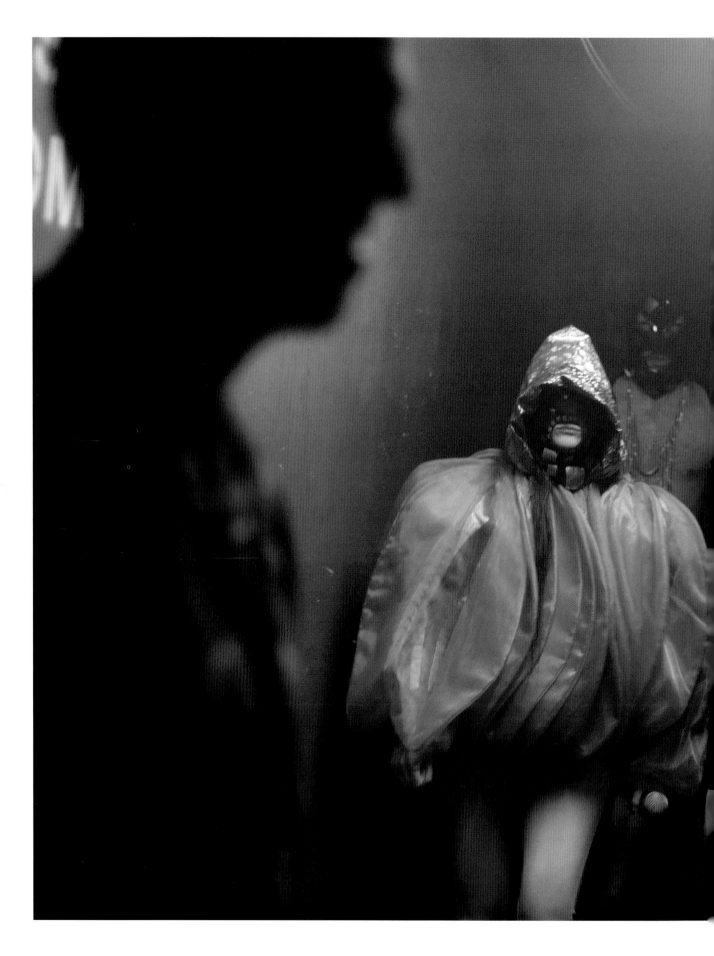

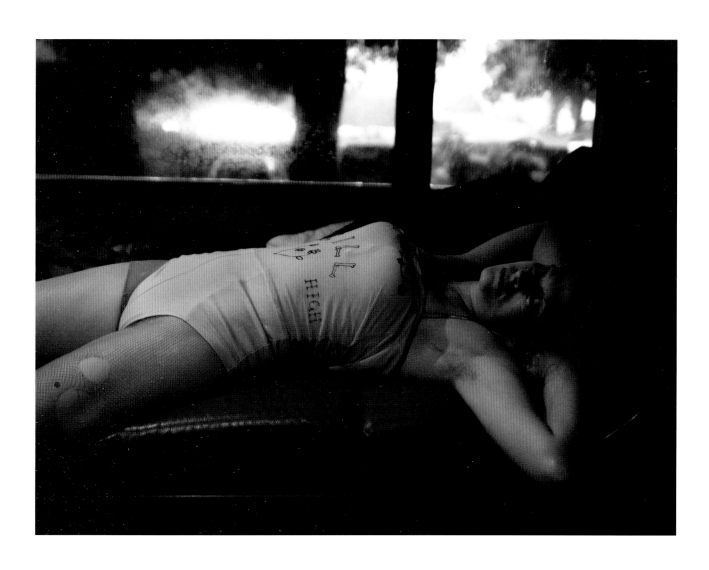

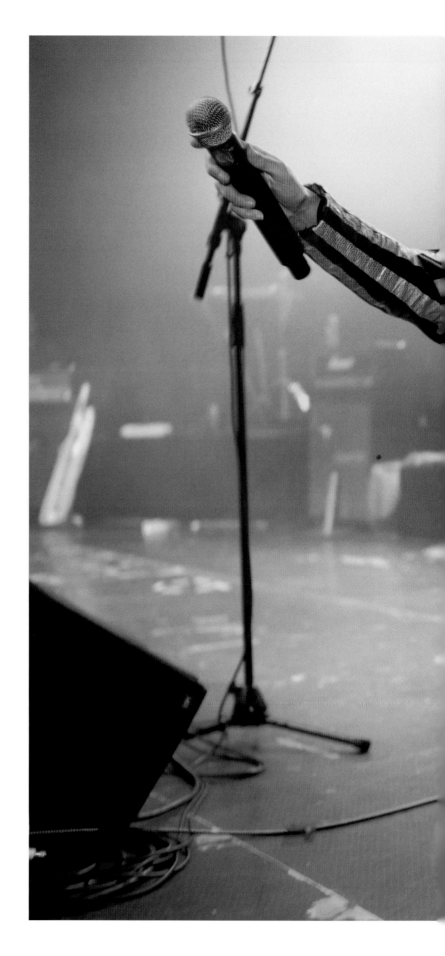

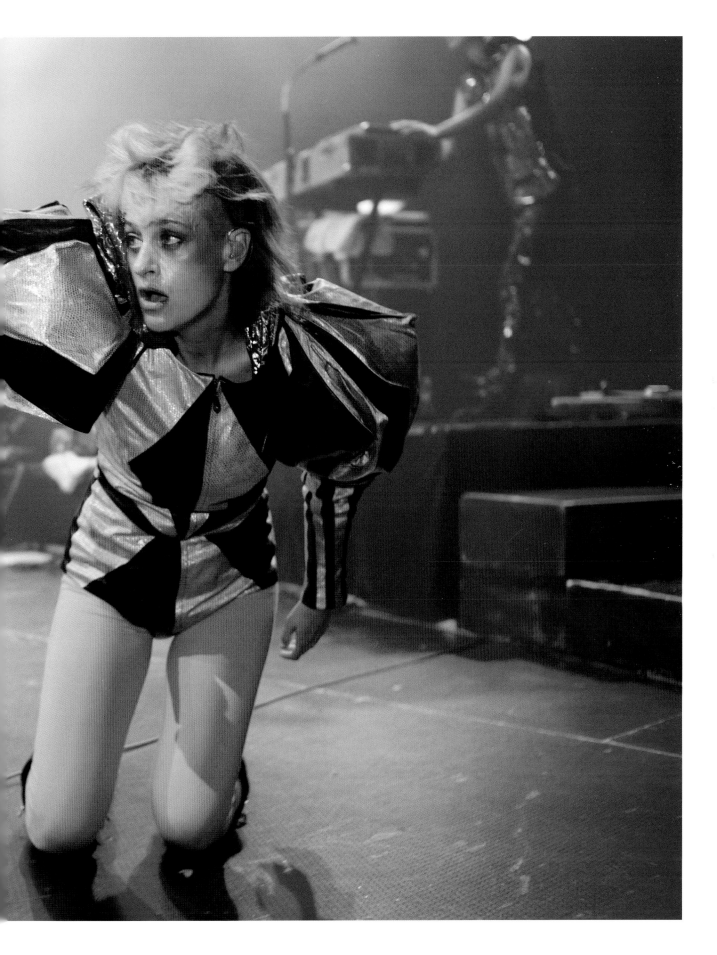

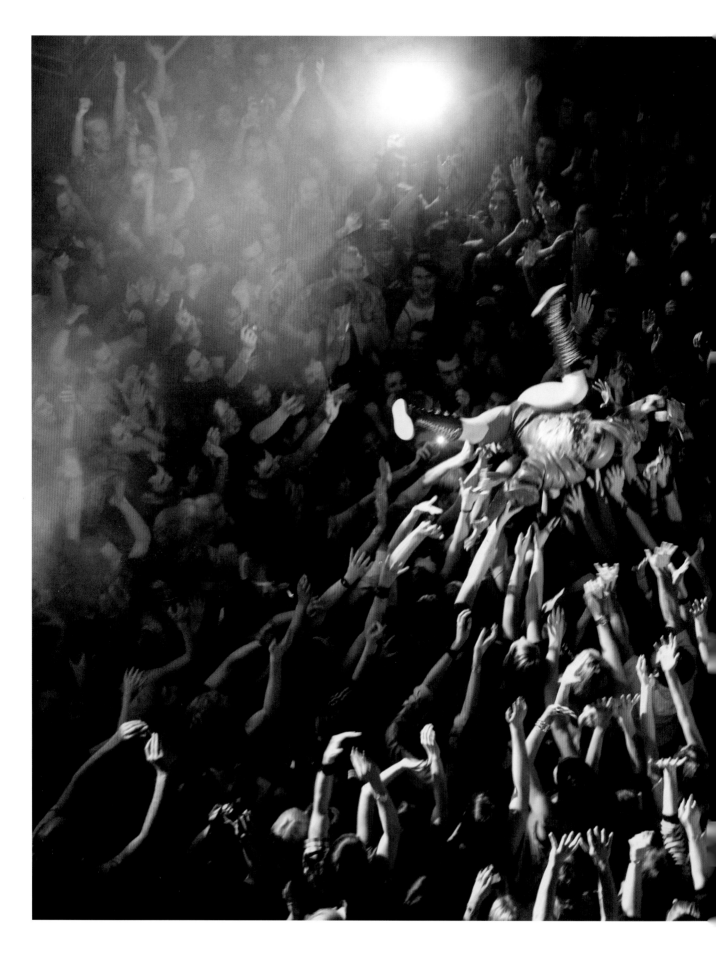

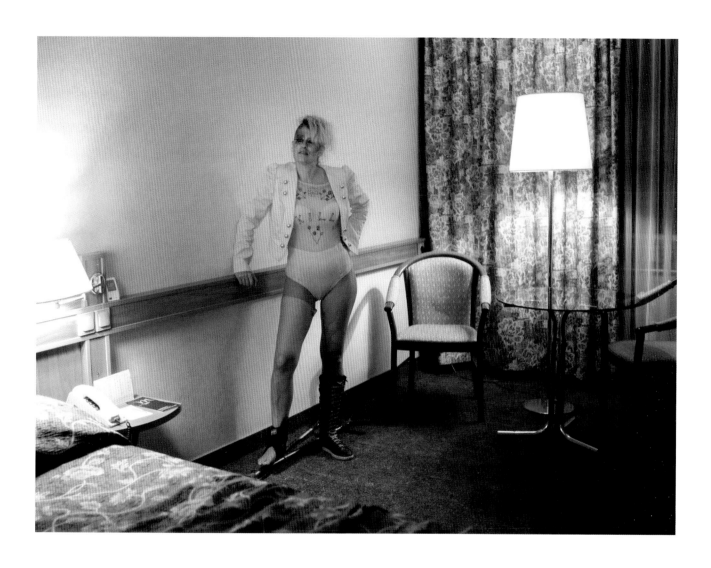

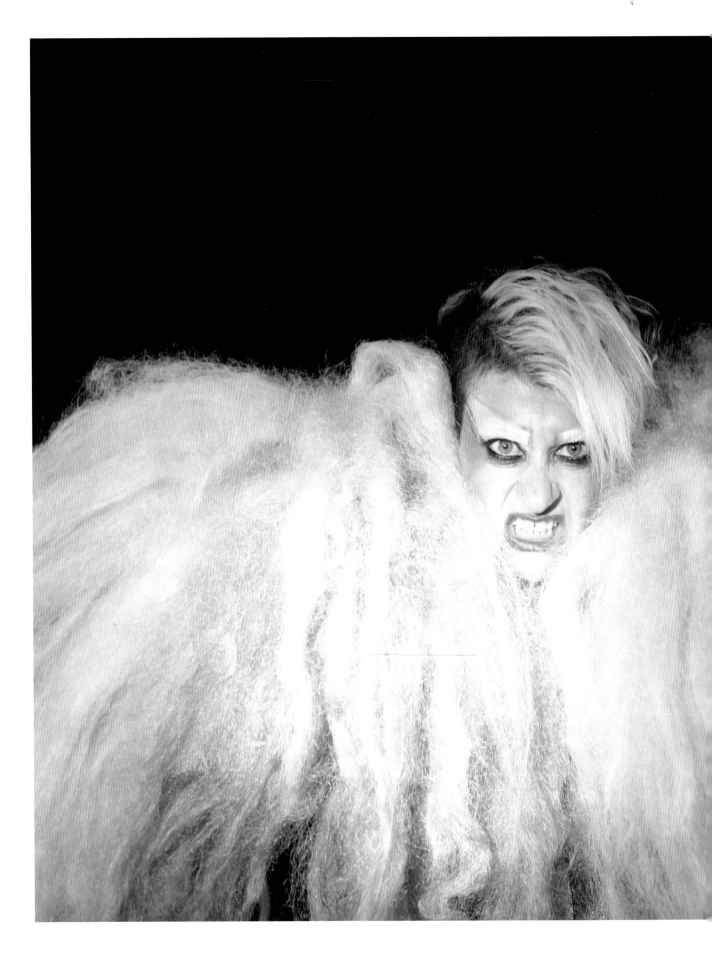

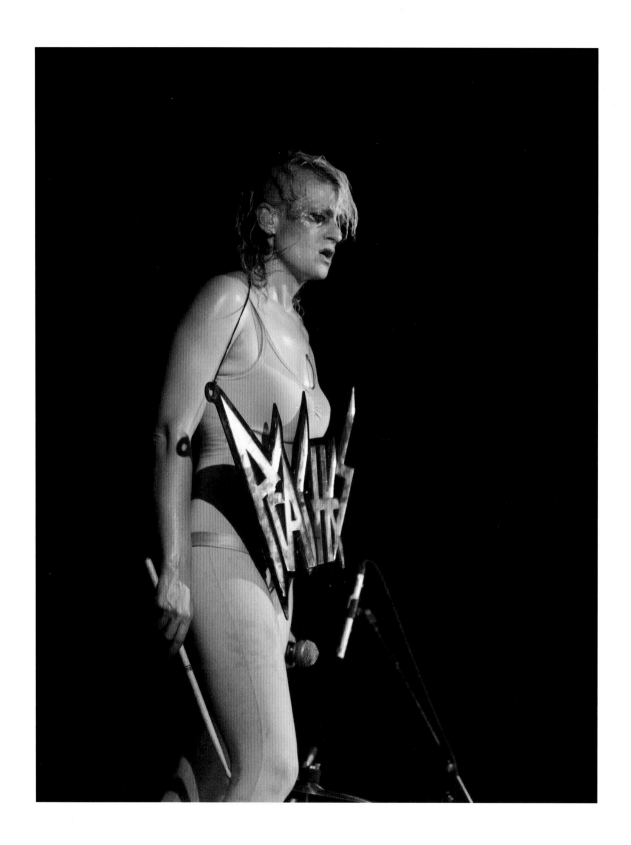

FOREWORD

PEACHES

By 2008 I had been recording and performing for eight years and I had just finished my fourth album, *I Feel Cream*. I was getting my new band Sweet Machine ready for our upcoming tour when photographer Holger Talinski reached out and said that he wanted to do a photo documentation of me. Great timing. I had always documented my tours as well as I could (mostly because I couldn't believe they were actually happening), and I had racked up around two thousand hours of video footage by that time. To have a photographer interested in capturing my travels in music and performance was a dream come true, especially since the *I Feel Cream* tour was my most ambitious tour to date. I didn't know Holger or his work at all, so of course there would be a trial period. I had no idea that it would end up being a six-year project.

I had always combined raw stage shows, performance art, and great musicianship, but it was reaching a whole new level with Sweet Machine. We had keytars and a Doepfer rod that had MIDI-controlled LED lights, and one little laser that could also be controlled by MIDI. Images of myself singing backup were projected onto my winged sleeves when I lifted my arms. There were costume changes galore where I would start with huge outfits and slowly, during the show, strip down layer by layer like a Russian matryoshka doll. Holger found a way to present every part of the show without ever getting in the way.

This was still a family operation. Fubbi Karlsson took care of the visual special effects. Vaughan Alexander, John Renaud, Jutta Pfeifer, and Charlie Le Mindu handled the costumes. Conner Rapp (also the band's keyboardist and bass player) managed all the musical programming—and now Holger would capture everything with his cameras.

It turned out that Holger was very easy-going—he was invited on many subsequent tours and quickly became part of our family. The *I Feel Cream* tour ended up lasting eighteen months, and we created three completely different live shows: the Main Show, the Wheelchair Show, and the Laser Show. The Main Show was just that, and included our usual performance elements. The Wheelchair Show, which lasted a month, happened spontaneously after I broke my ankle during a performance and had to construct a new approach, which included my

old performance collaborator Mignon as the fake Peaches, my niece and budding rock star Simonne Jones as my shadow, and Danni Daniels as the naked-nurse wheelchair driver.

The concept for the Laser Show came about when Vice Media asked me to do a collaborative project with their art and technology platform, the Creators Project. Essentially, they gave me a bunch of cash to do whatever I wanted. With this, I had three laser harps built. Sweet Machine and I learned how to control them, and we constructed a show solely playing lasers. It looked awesome and was a thrill!

I was planning to take a break after this very intense tour, at which point Holger's documentation would come to an end. Yet the break instead evolved into even more new projects.

In 2010, Matthias Lilienthal, the artistic director of an innovative theater in Berlin called HAU (Hebbel am Ufer), asked me to stage my own production. What immediately shot out of my mouth was that I wanted to do *Jesus Christ Superstar* as a one-woman show with a piano player. Matthias responded, "Yes, but I want you to do a bigger production later on, we have funding." When I told my close friend Chilly Gonzales about my plan for *Peaches Christ Superstar*, it turned out that he was also a fan of the musical, and he promptly volunteered to be the pianist for the show. Chilly and I had done so many crazy performances together in the early 2000s, so I knew this new collaboration would flip people out. Those who remembered us as a rap duo would see a whole new side: Chilly is a phenomenal pianist, and no one was aware of my true vocal range.

We did two runs and they were extremely successful. Then came the bigger production. I decided to use this show to celebrate my ten-year anniversary as "Peaches" and to write an original electrorock opera called *Peaches Does Herself*. The story was to be told through song alone, with material selected from my four albums arranged as a narrative. It ended up being an incredibly huge, labor-intensive project and brought the family together again, but this time as a much larger extended family.

The stage show ran in October 2010. What a rush! I asked videographer Robin Thomson to document it just for kicks, and when we watched the footage we realized that it could actually be turned into a movie.

For the second run, in March 2011, we planned better filming angles during the show and also ran certain scenes the day before the shows so that we could show close-up shots during the performances. Conner Rapp recorded the shows live every night, and later turned his apartment into a surround-sound studio to begin working on the movie.

I also changed the ending of the play to better suit the filming, which helped transform the footage into a "real" movie. There were 1,500 edits. Color correction was a bitch, but we finally had *Peaches Does Herself* ready for premiere at the Toronto International Film Festival (TIFF) in September 2012. (The movie was well received and ended up traveling the globe to around seventy film festivals in 2013.)

In 2012, the HAU theater asked me to take part in a new production. This time I would not direct but was given the lead role of L'Orfeo in the original opera of the same name. I would sing the Italian male leading role with five other trained opera singers, along with the incredible soloist ensemble Kaleidoskop as the orchestra. I did not know how to read sheet music and I could not speak Italian, so I trained with Timo Kreuser for six months to learn the melodies. Another landmark experience.

I had also been getting many requests to DJ. It's an easy enough thing to do, but I always found that people were not quite satisfied seeing me spin tracks without singing. I found it increasingly frustrating to deflect these fans so I created a hybrid DJ/MC show and called it *Peaches DJ Extravaganza*. This turned into a whole new performance project that I presented many times between 2011 and 2014. It's a self-contained show, reminiscent of my earlier solo performances, and I asked two East German dancers, Ginger Synne and Frau Pepper, to join me; we have now traveled the world together. Other dancers who have joined this show include Louise de Ville, Clea Cutthroat, Jess Daly, and Agent Cleave. Jess Daly, on her own volition and as a labor of love, created new costumes for me for this show. She made the now iconic tit costume, which is a breast plate–shoulder pad outfit with thirty boobs, all with Barbie heads as the nipples (each with individually styled haircuts).

Still other projects were happening at this time. In 2012 I was moved, as were many, by the indecent treatment of the all-female punk band Pussy Riot and their incredible fight for freedom in Russia.

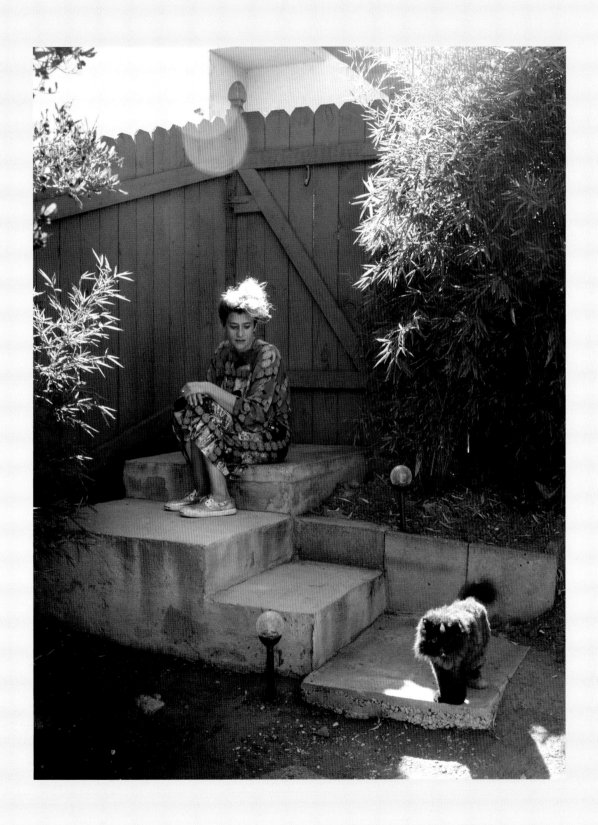

I organized a small protest that turned into a four-hundred-person peaceful happening, and a video of this helped raise awareness and money for the band's legal fees. I also mentored and produced an all-girl band from Taiwan called Go Chic who came to Berlin to work with me.

In 2013, Yoko Ono celebrated her eightieth birthday in Berlin with a Plastic Ono Band performance. She asked me to pick my favorite Yoko Ono song and perform it with her. I sang "Yes, I'm a Witch" onstage with her. YES! Later that year, Yoko was asked to curate the ten-day Meltdown Festival in London. She had me join the Plastic Ono Band again and also asked me to perform her famous *Cut Piece.* I sat on a stage alone in an evening outfit with a pair of scissors in front of me. Audience members would approach the stage one by one and cut the clothes off me as I remained perfectly still. It turned out to be the most powerful performance I had ever experienced.

And it didn't stop! I spent 2014 in my new garage-turned-studio in Los Angeles working ten-hour days on completing my fifth album, with director Vice Cooler. Now, here comes another tour . . .

So why am I telling you about all this shit? Well, it's because Holger Talinski was there with his camera throughout. He captured all these moments, both the magic and the realities. Holger shows the exhaustion, the work, the relaxation, the elation, the parties, the quiet moments, and the family visits. It is amazing for me to look back at these photos and understand how much I have packed into these years. I seriously don't even know how I got all of it done, but I did, and looking back helps me realize how proud of it I am. I am grateful for this gift Holger has given me and I hope you enjoy this book again and again.

Berlin, Germany

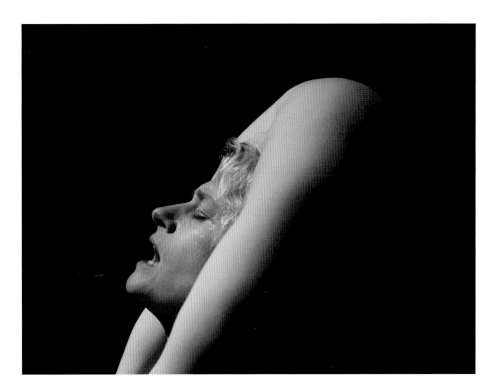

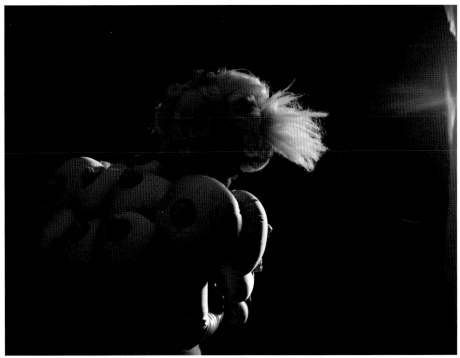

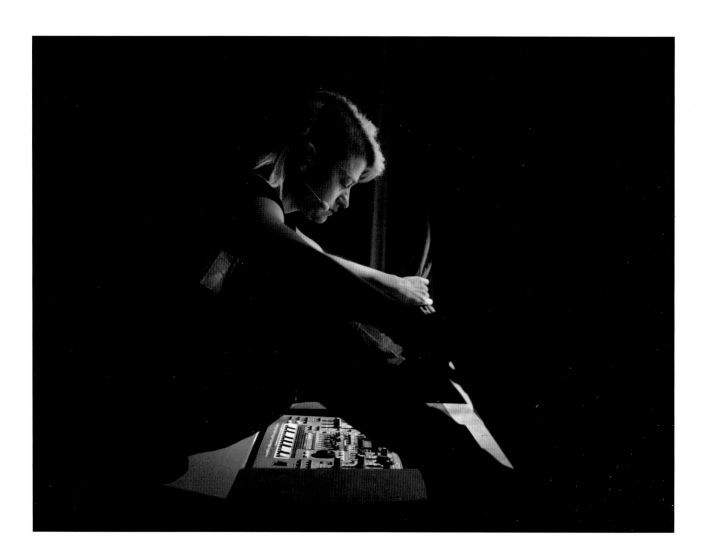

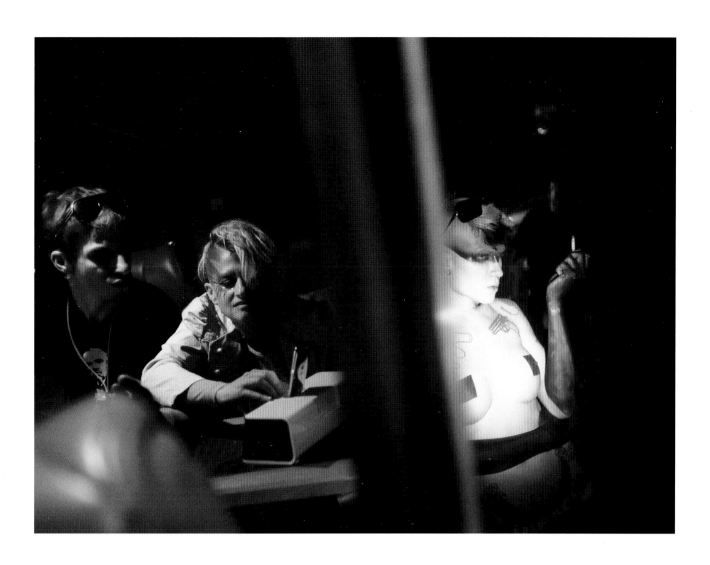

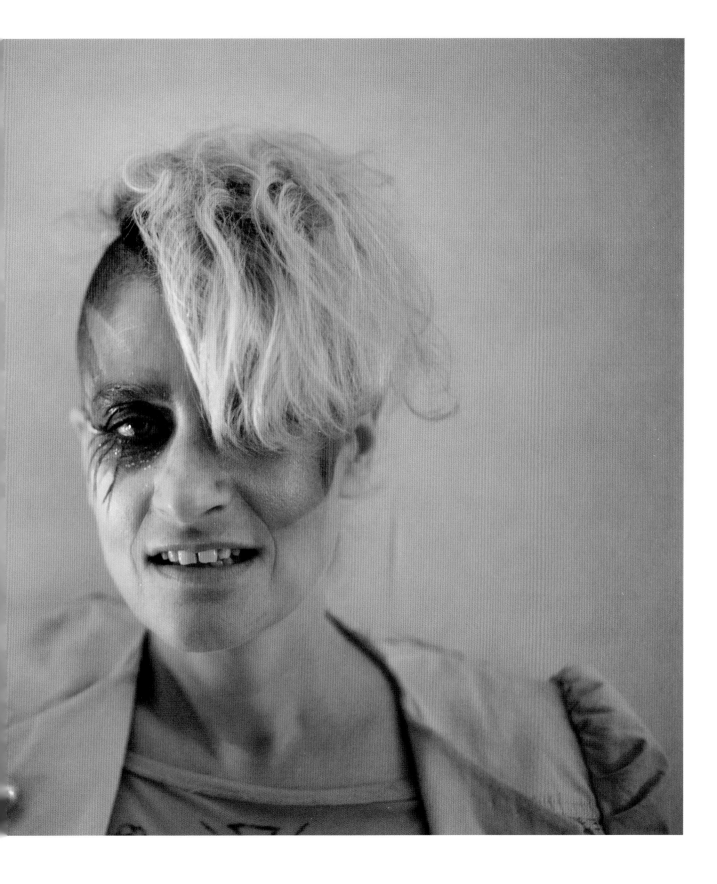

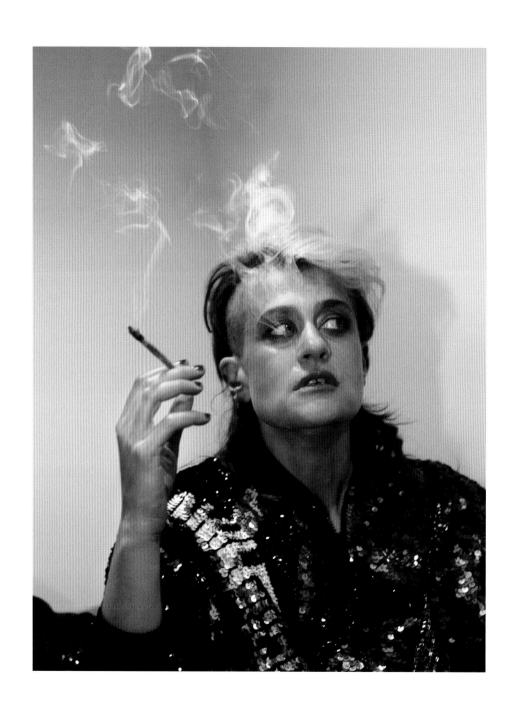

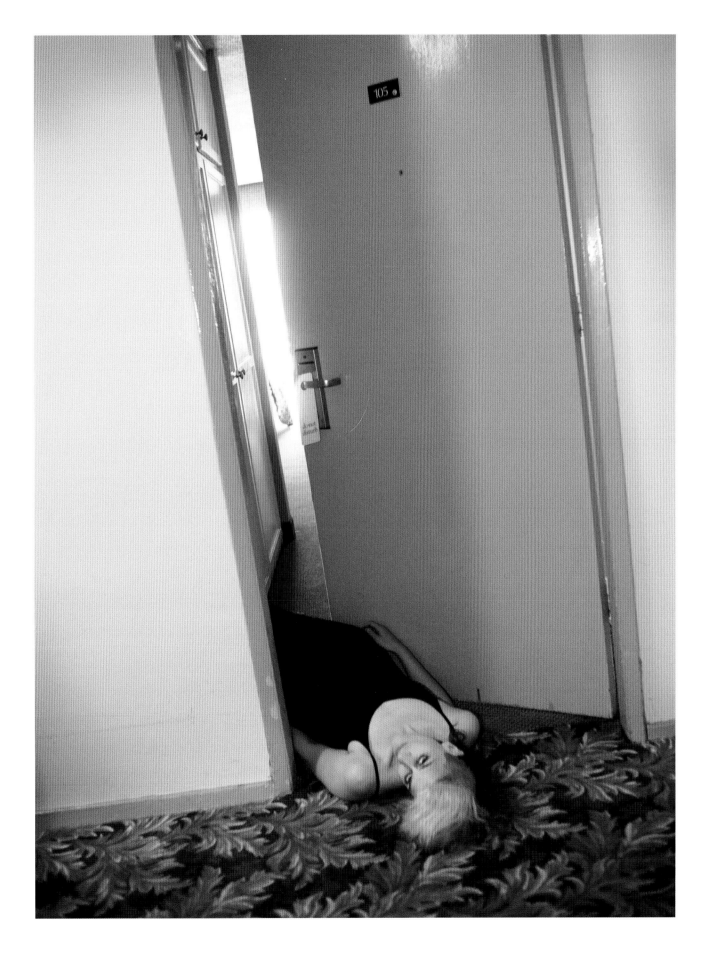

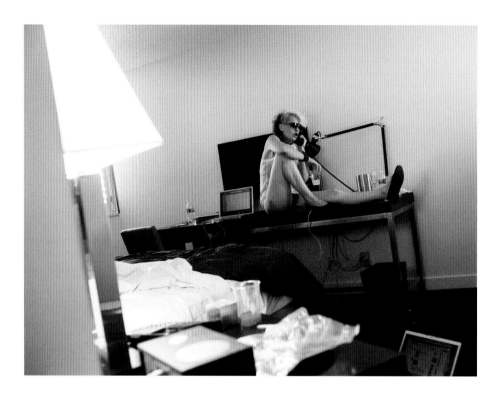

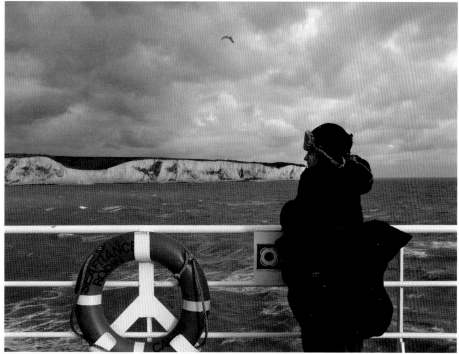

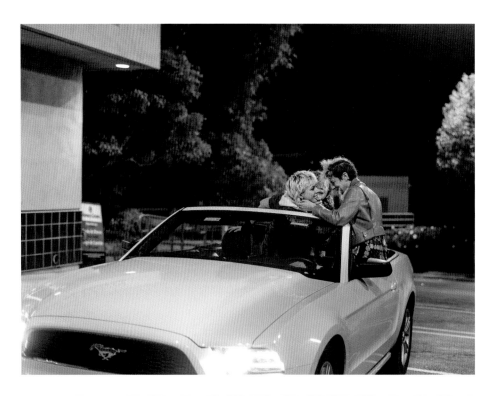

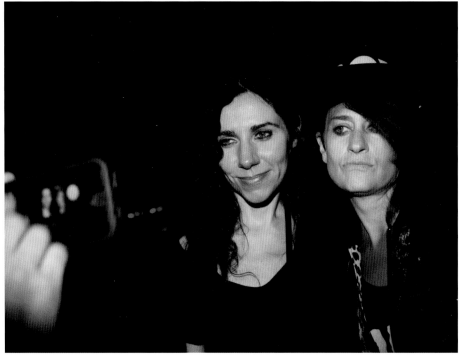

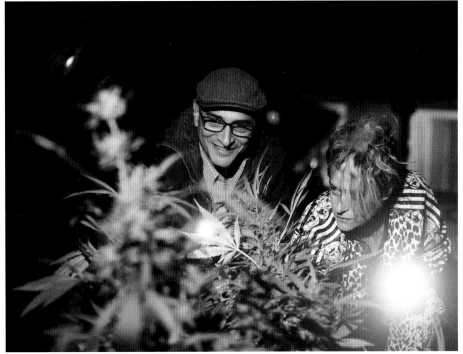

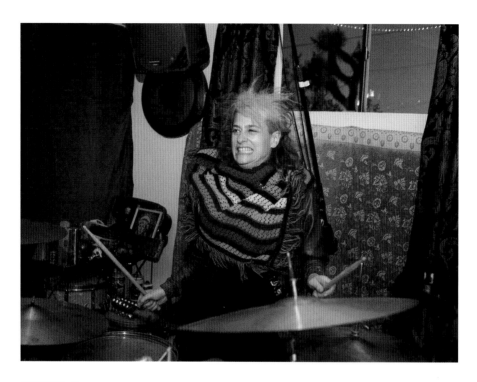

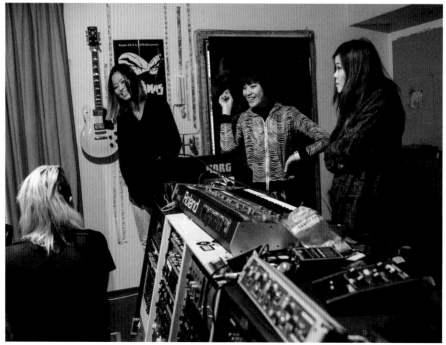

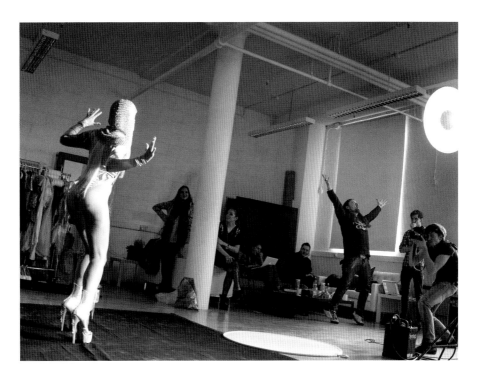

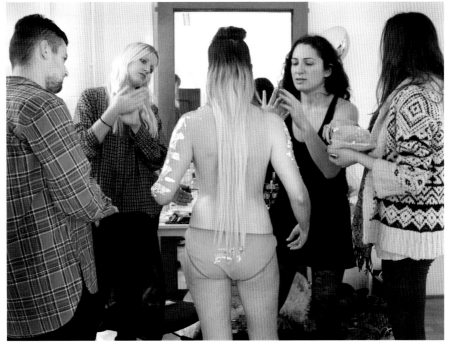

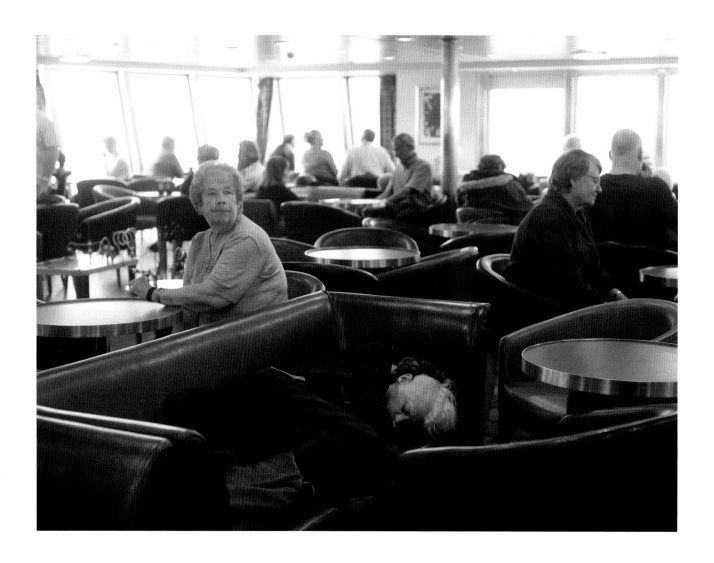

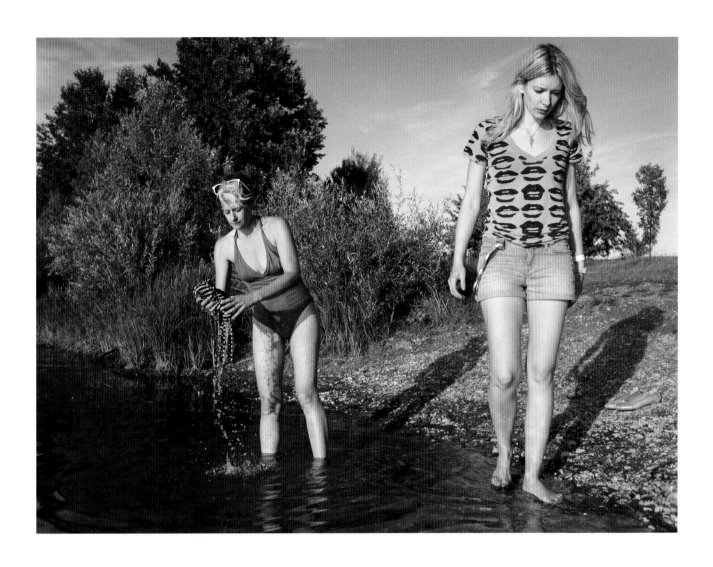

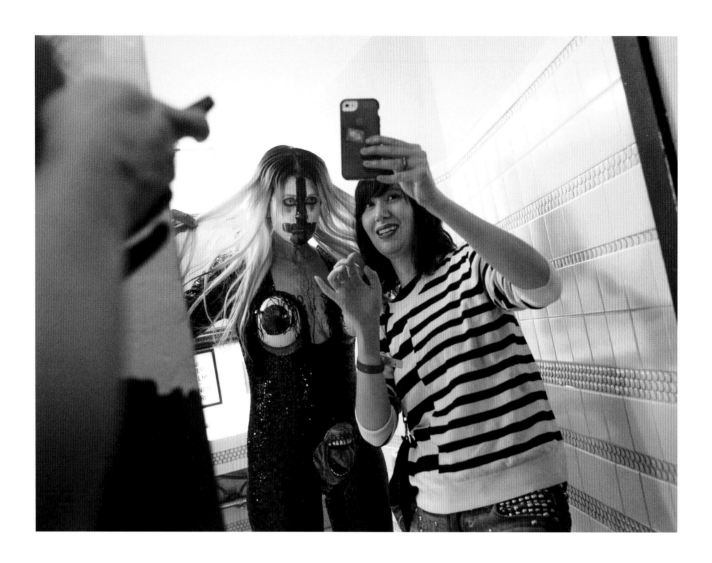

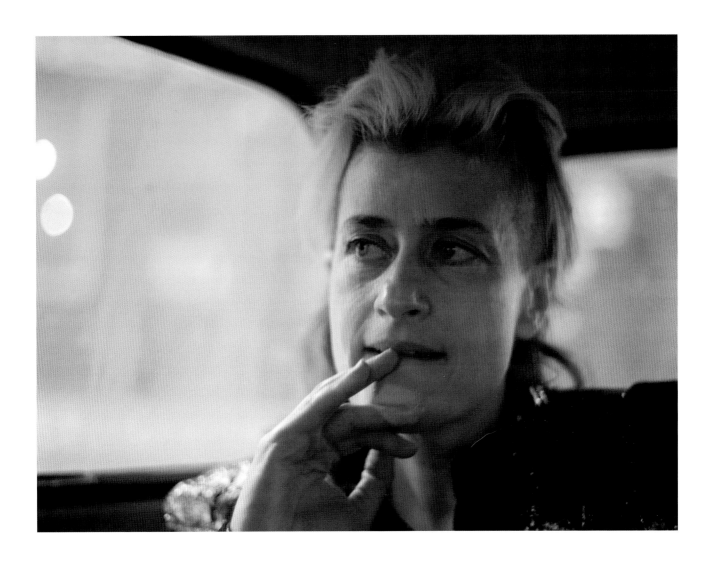

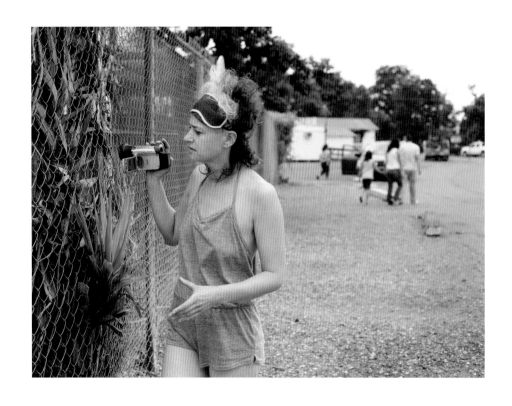

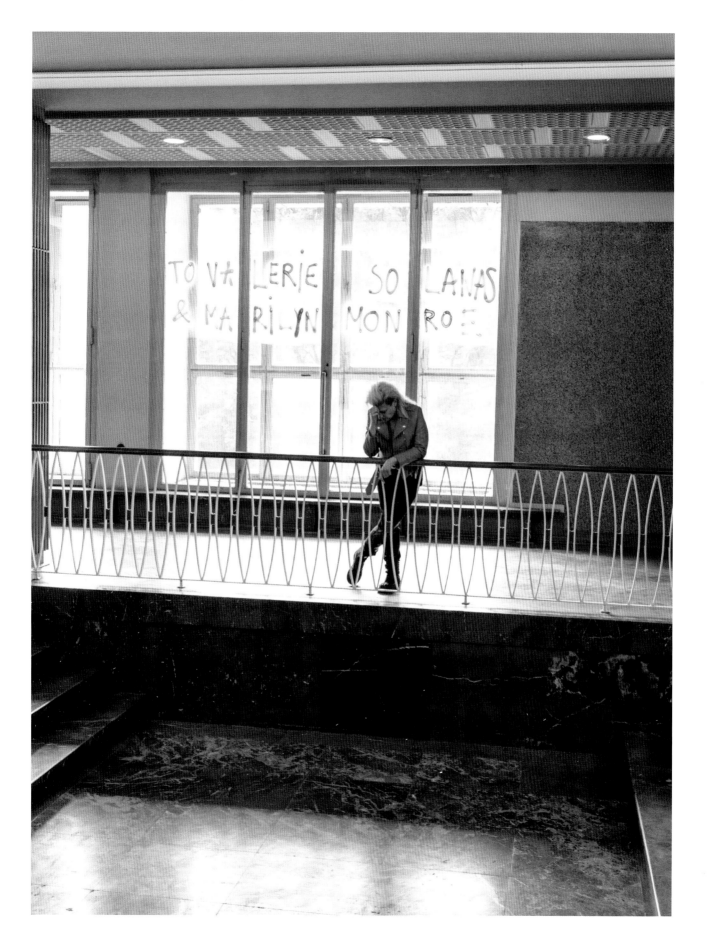

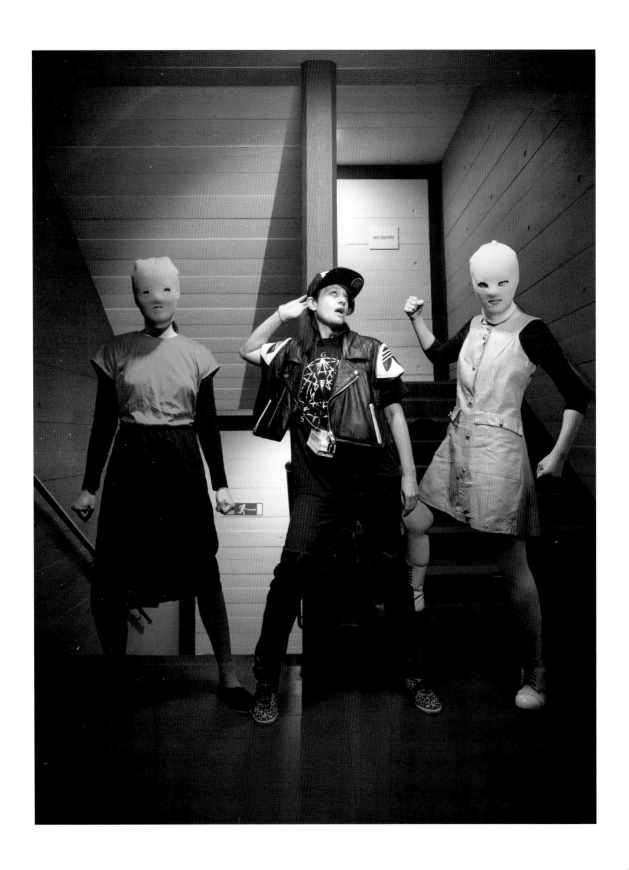

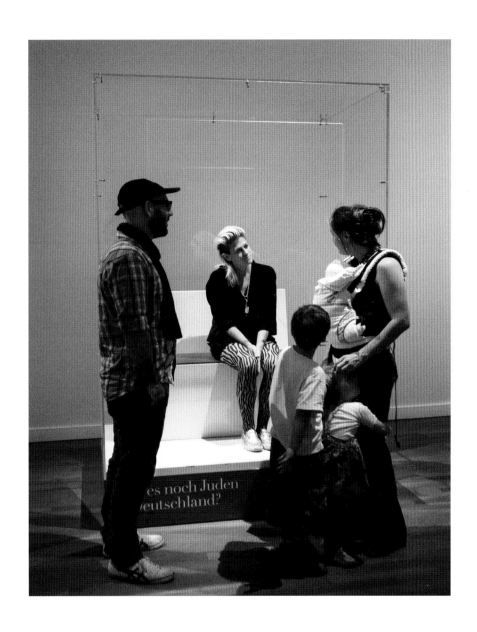

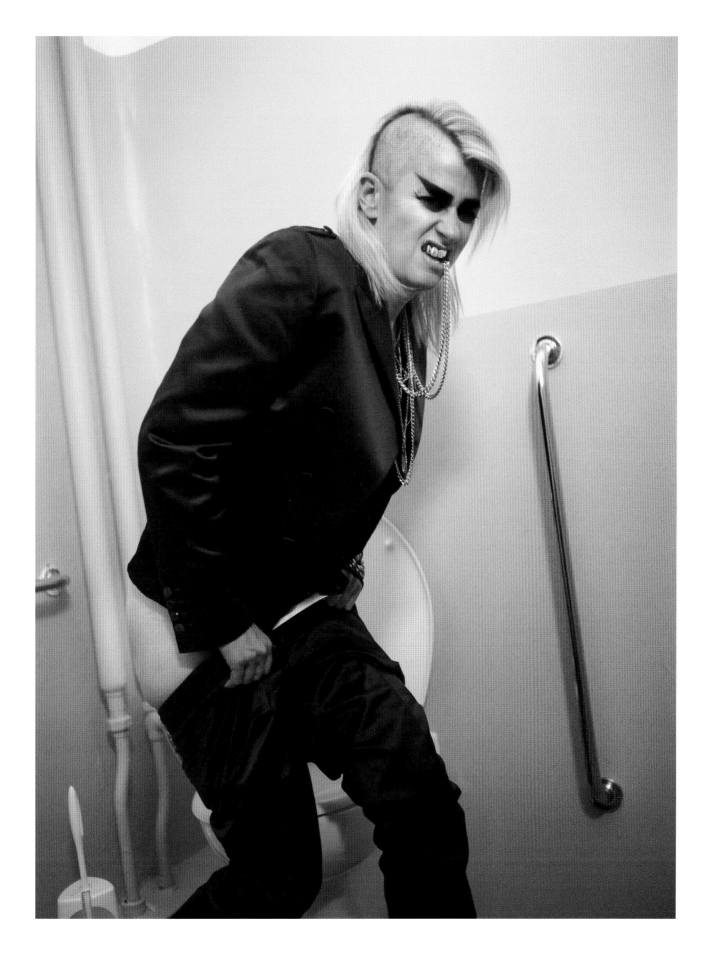

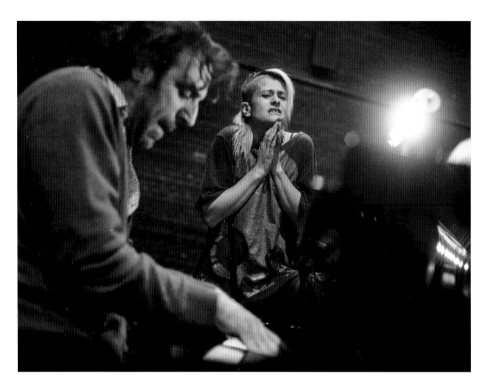

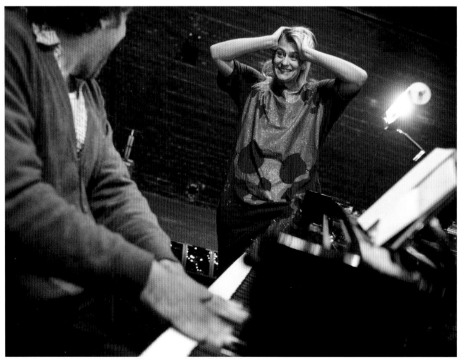

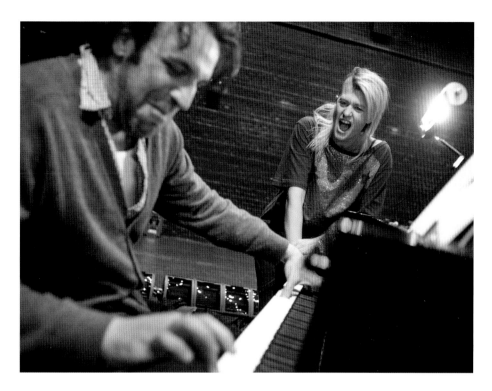

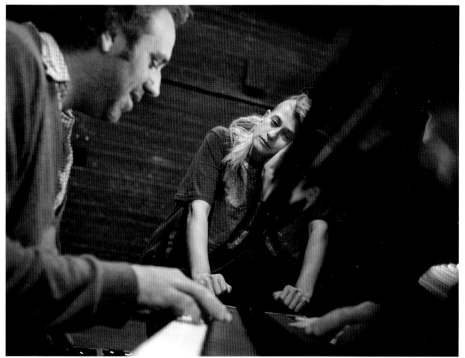

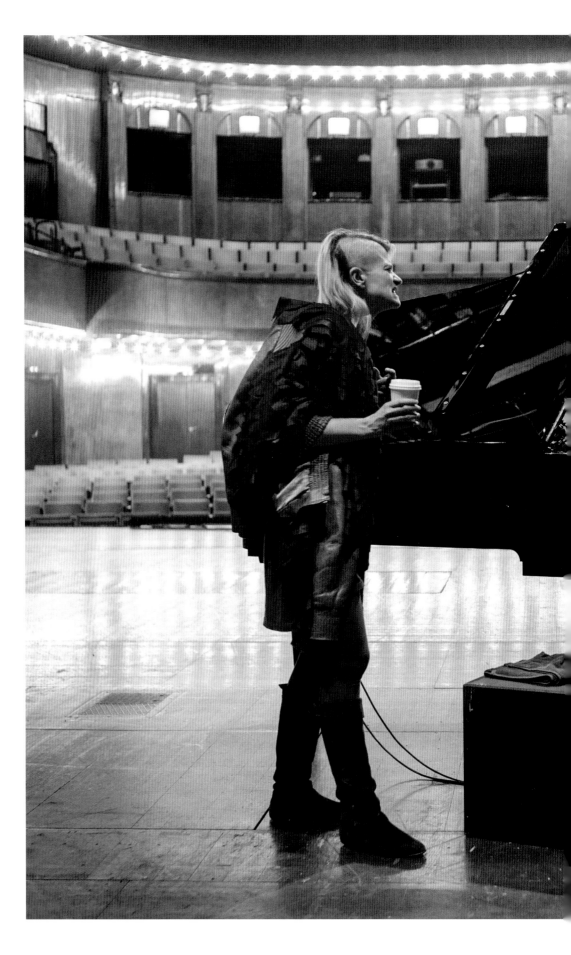

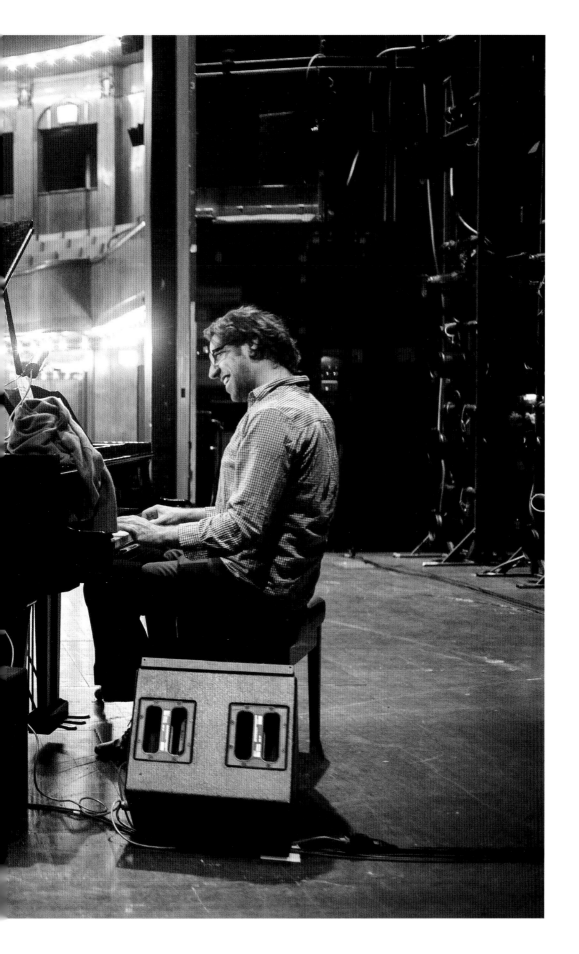

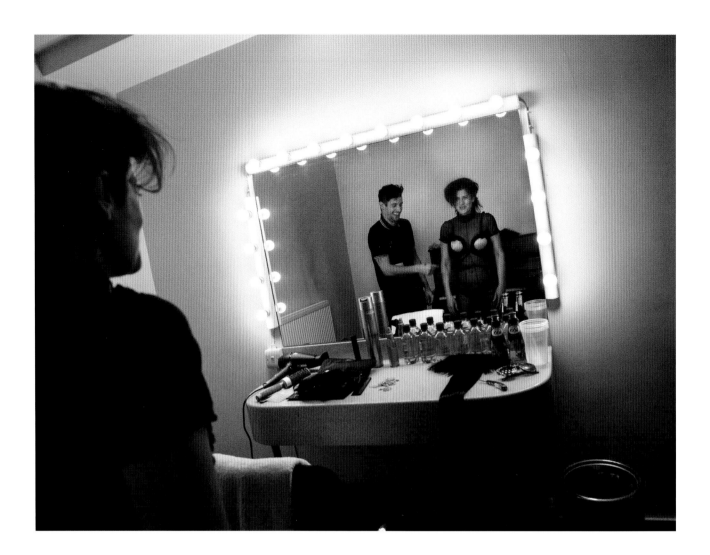

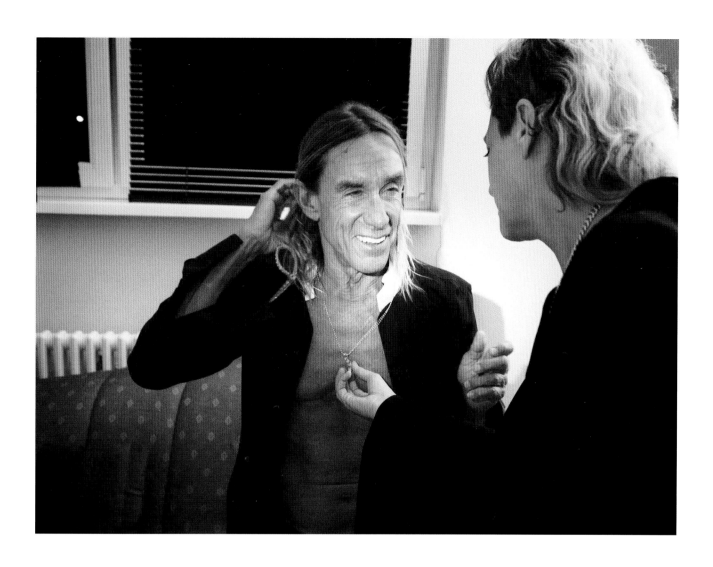

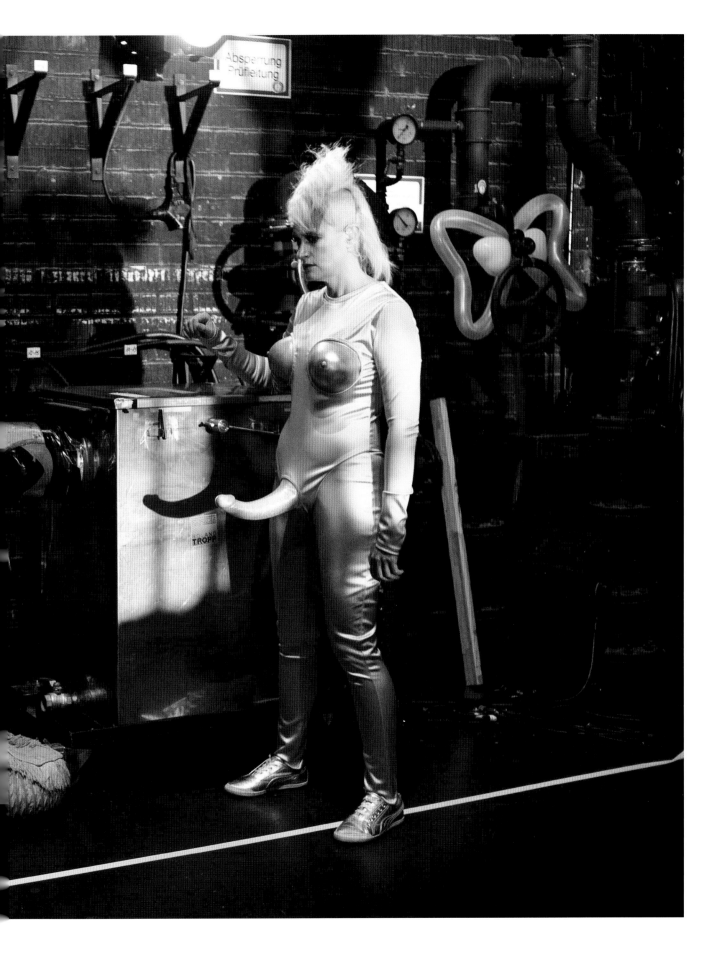

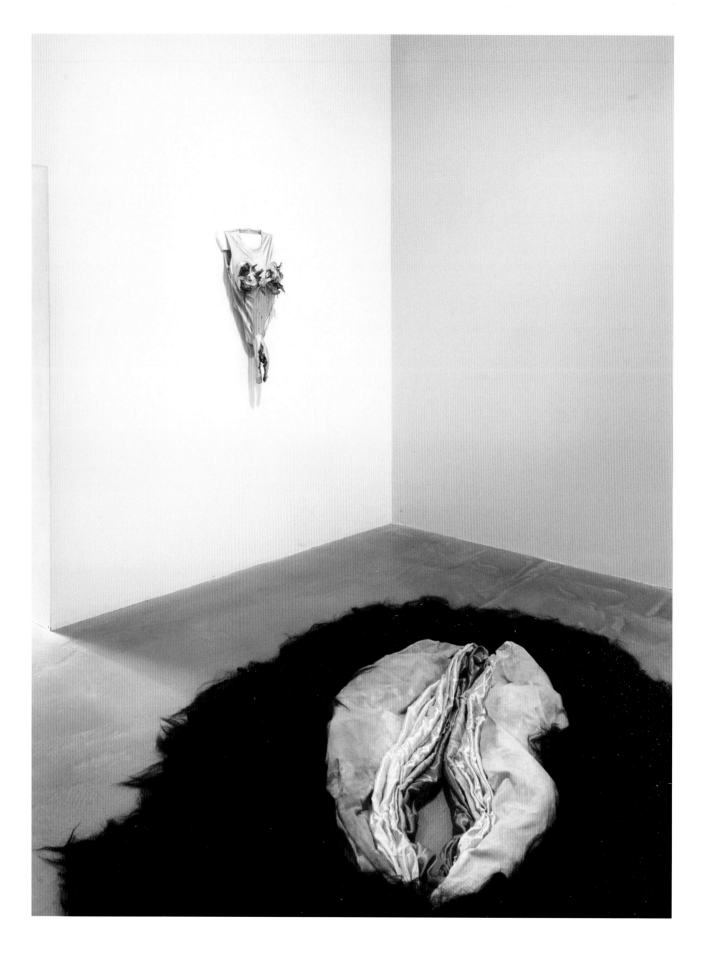

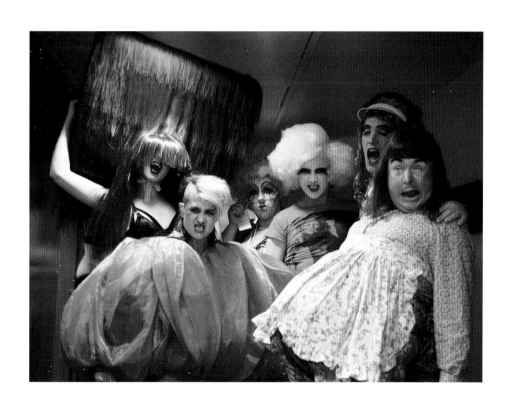

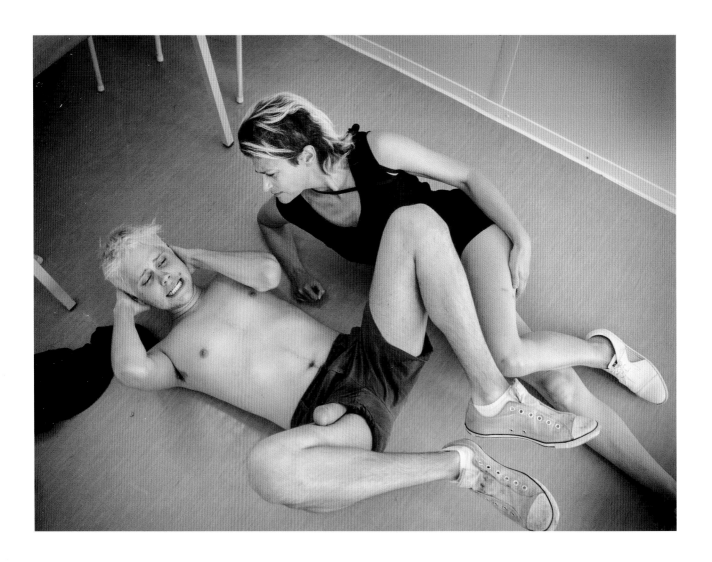

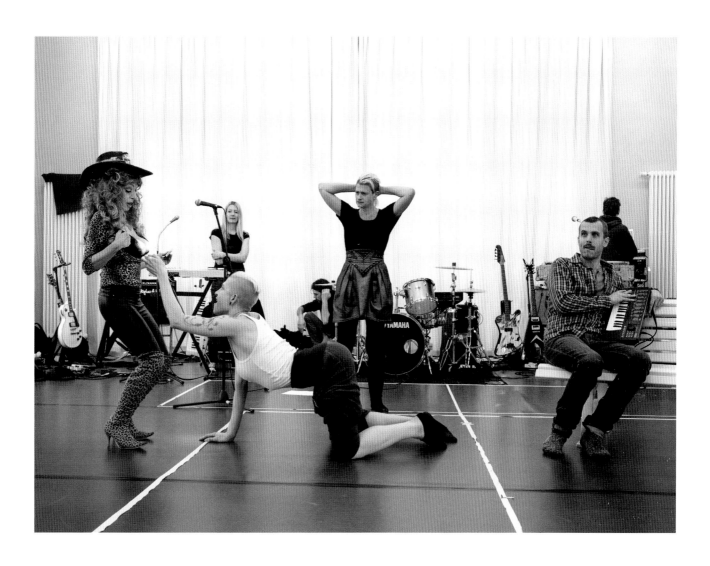

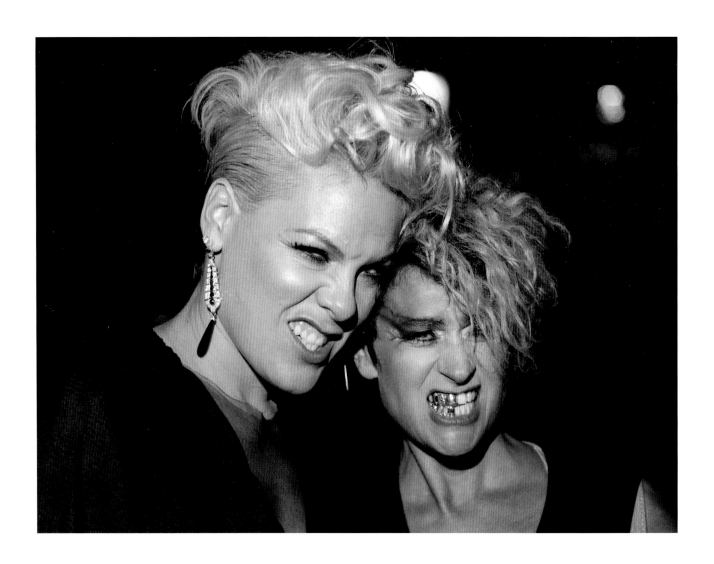

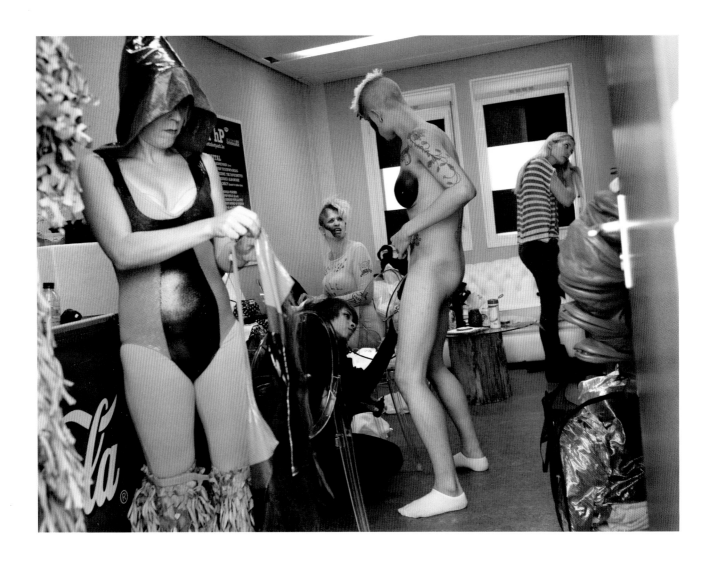

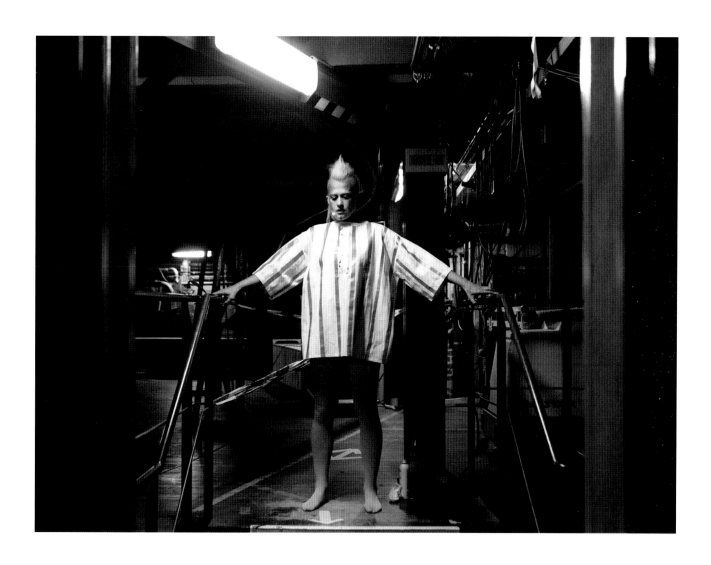

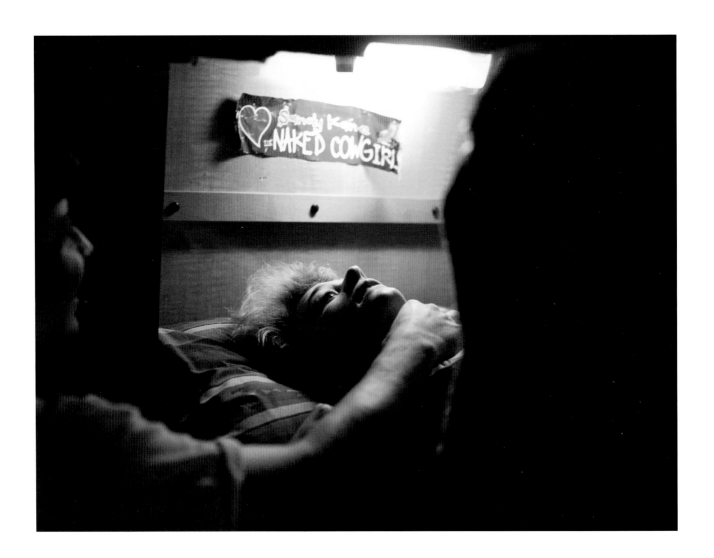

SHE SAT QUIETLY BUT HER BODY WAS EXPRESSING A UNIVERSE

YOKO ONO

Peaches performed my work *Cut Piece* at the Meltdown Festival in London in 2013. There was a lot of talk about it. "Do you think she will?" "Yeah, I think she will." "I don't think she will—it's not an easy piece . . ." That sort of talk. I thought it was interesting that all this was said in whispers. It seems that the piece demanded to be whispered about.

Backstage, Peaches casually said she didn't have any problem getting totally naked. When she was finally on the stage, I realized what she meant. She sat quietly but her body was expressing a universe. Sensitivity, vulnerability, strength without trying—all with dignity, representing us women. *Cut Piece* will never be performed again with such eloquence, I thought. What I discovered in Peaches was the new-age performance artists and how they are. They

are not scared of being beautiful and showing it. Whereas we, the past feminists, thought it was important to look like soldiers if we wanted to be taken seriously. No more. Women are not scared of showing their vulnerability either. Not scared of letting their intelligence shine. And not scared of just being themselves instead of constantly being apologetic to the male species, or being rebellious.

All that was expressed by Peaches, sitting on an otherwise totally bare stage. I don't think a symphony could have matched what she did. She is an incredible artist. Seeing her do *Cut Piece*, and later, after attending her own shows, I have a clear vision of future women artists led by the creative courage of Peaches. Thank you, Peaches, for adding a long and exciting life to performance art.

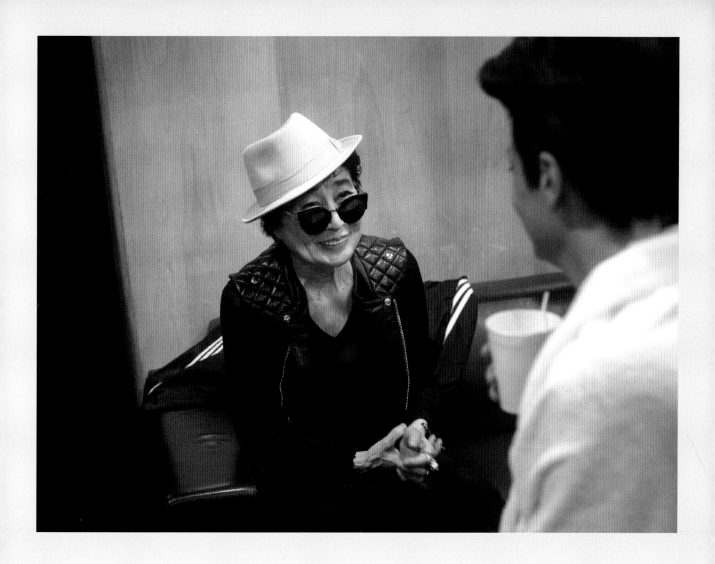

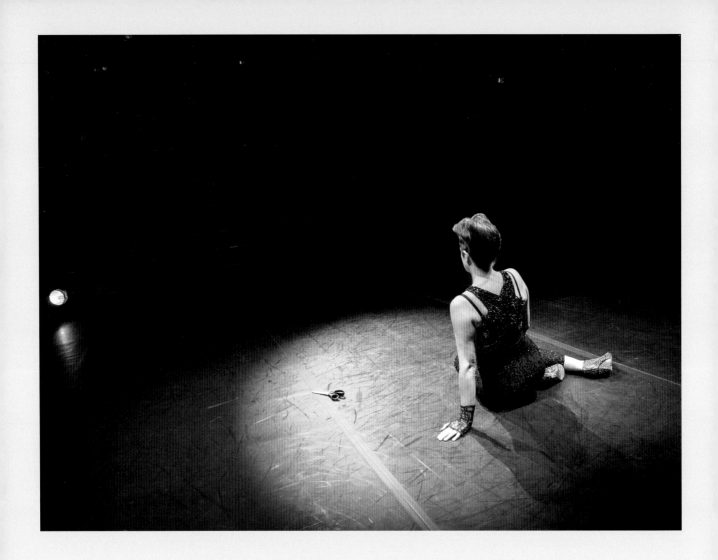

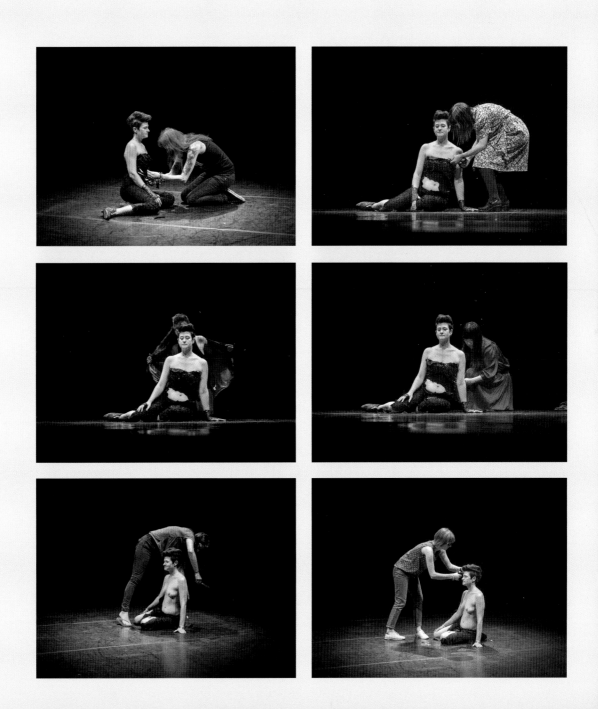

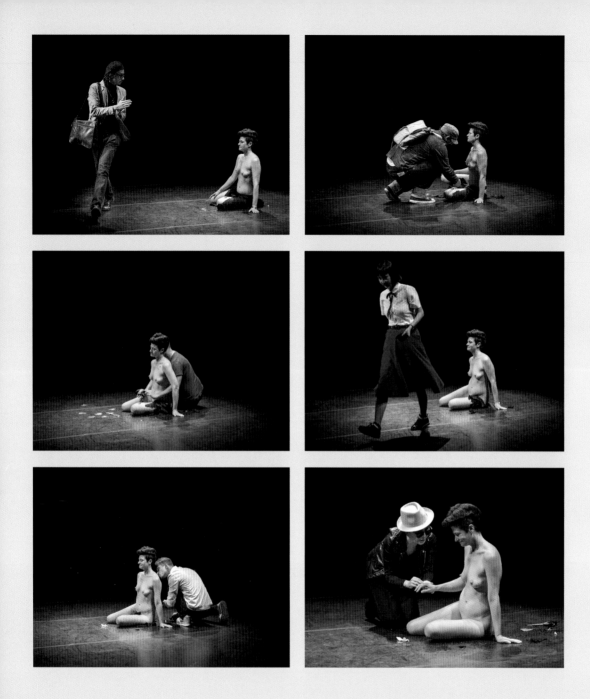

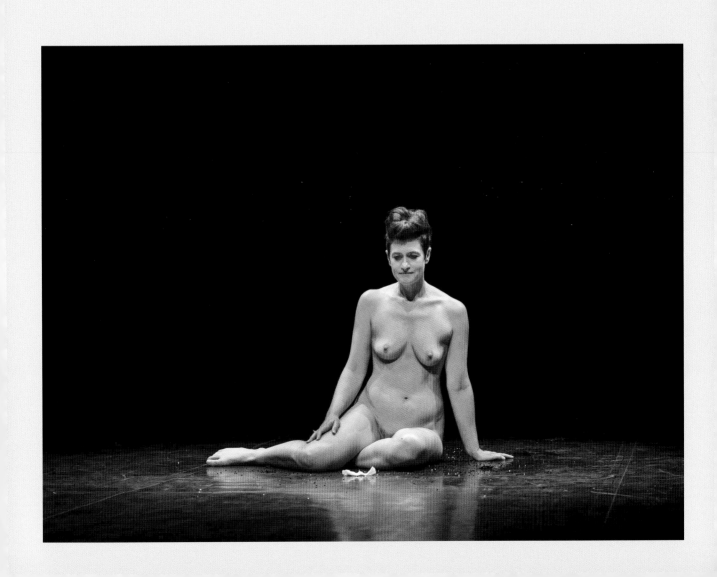

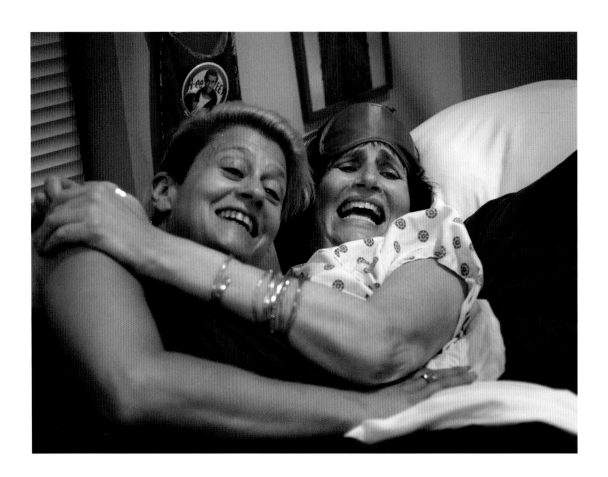

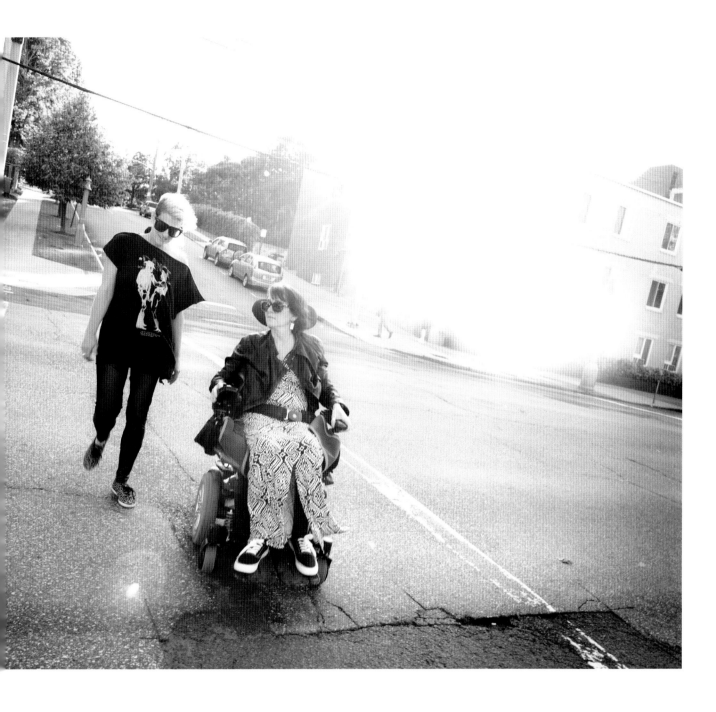

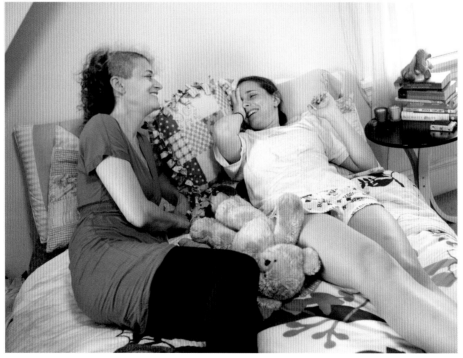

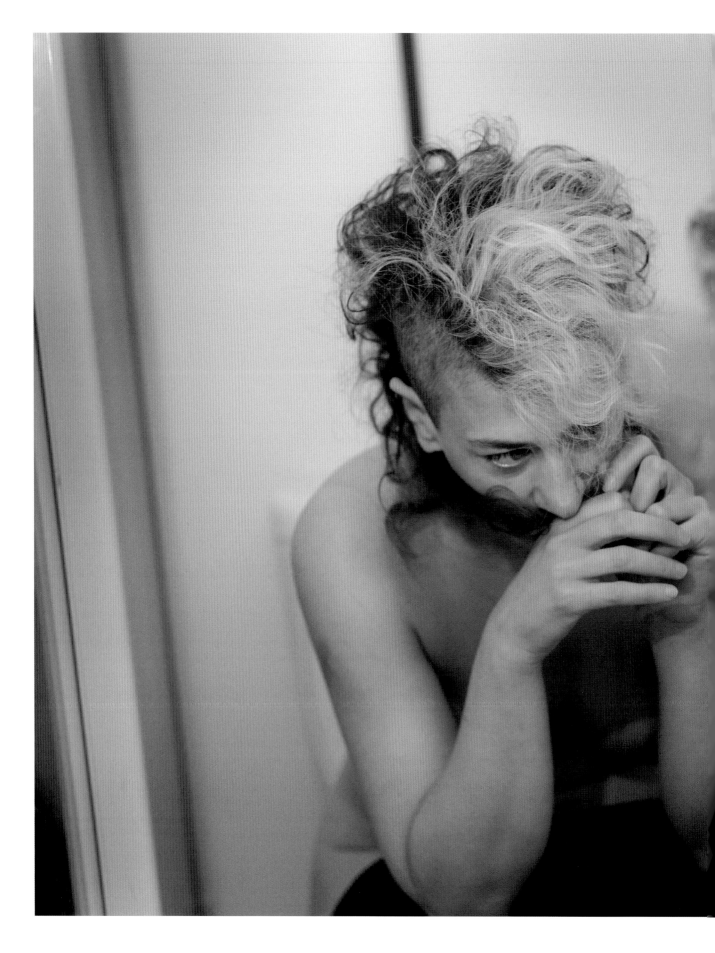

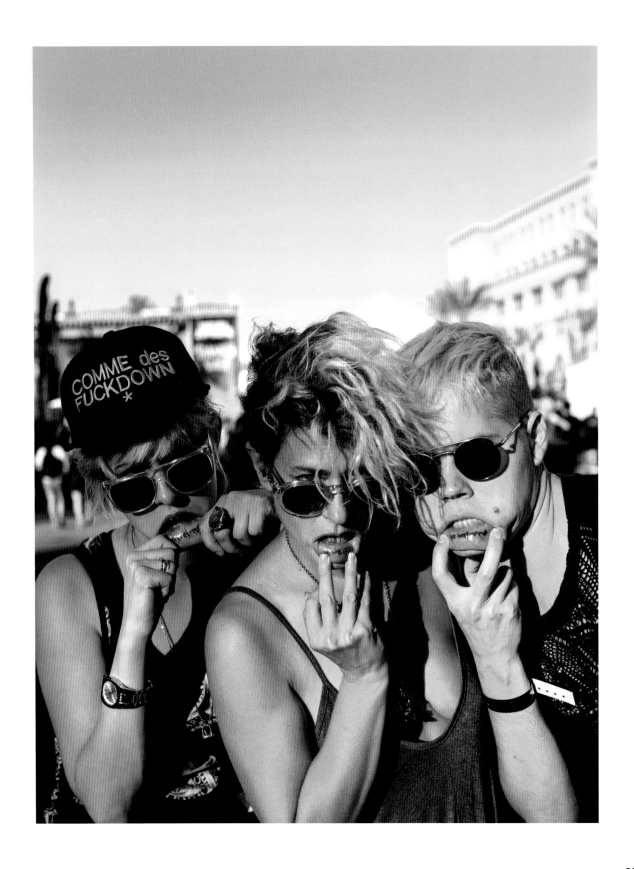

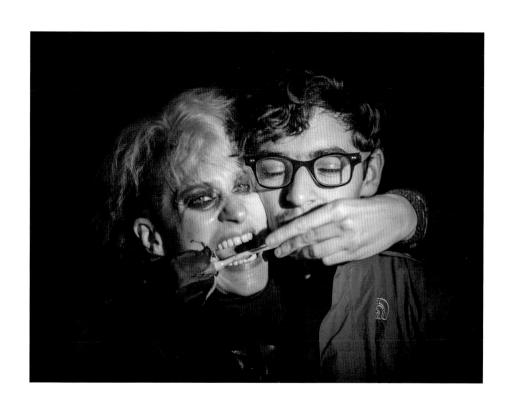

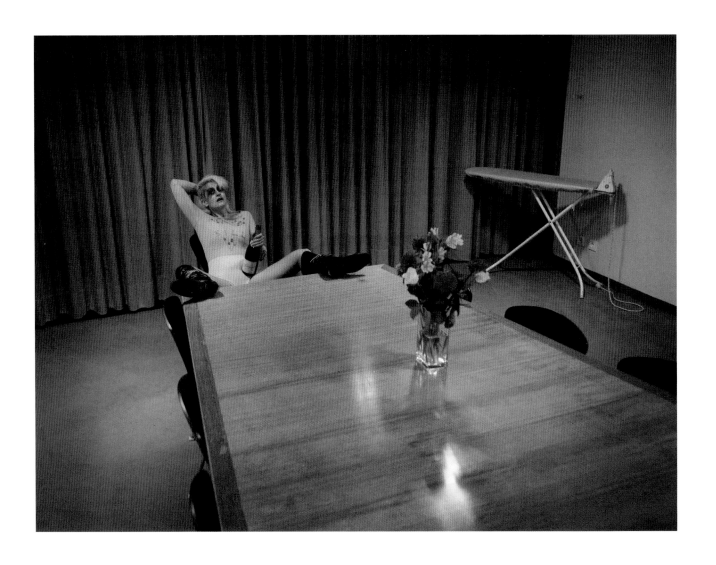

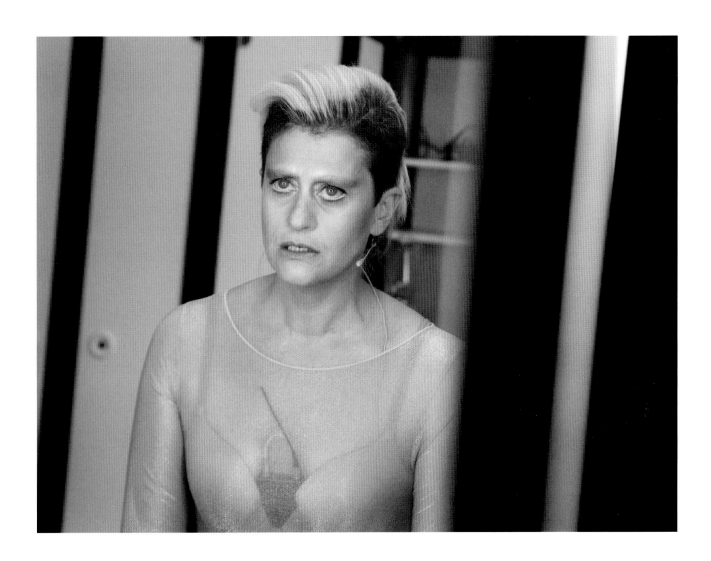

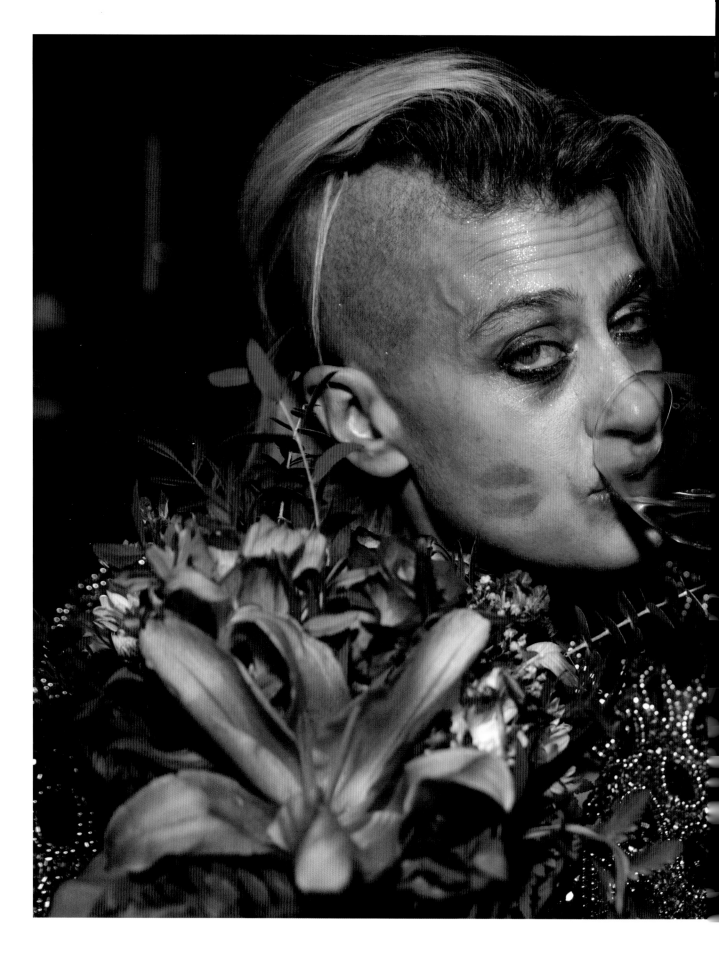

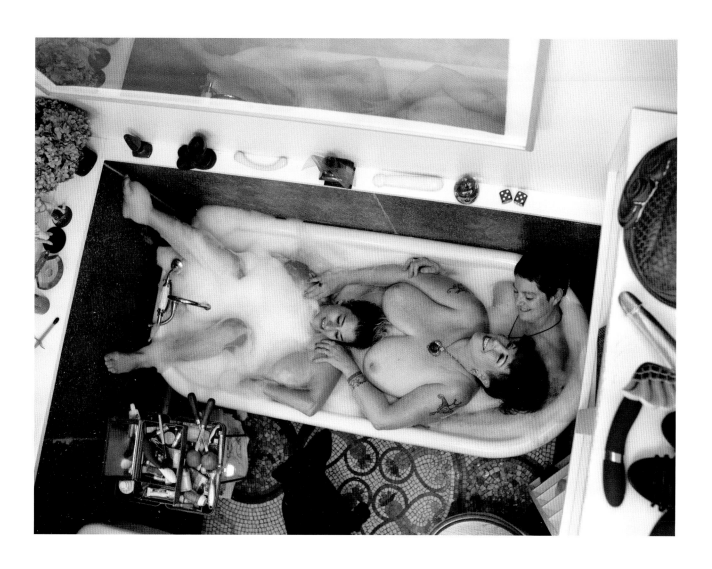

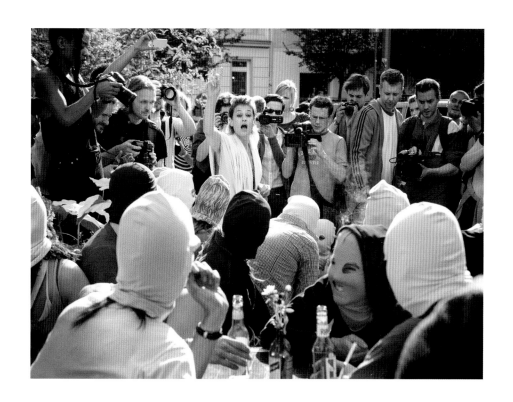

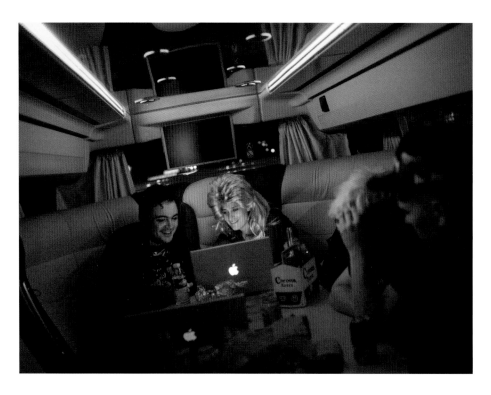

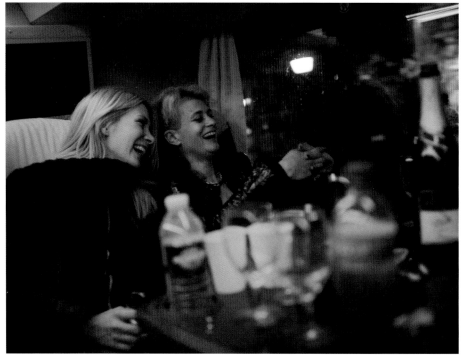

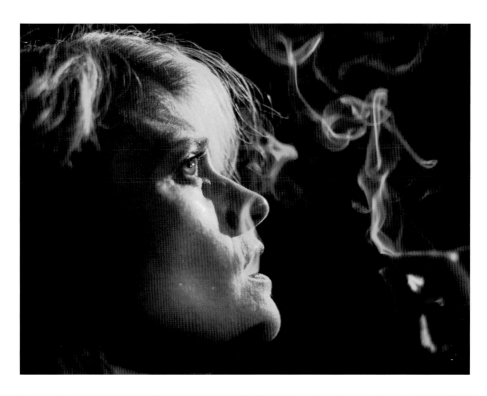

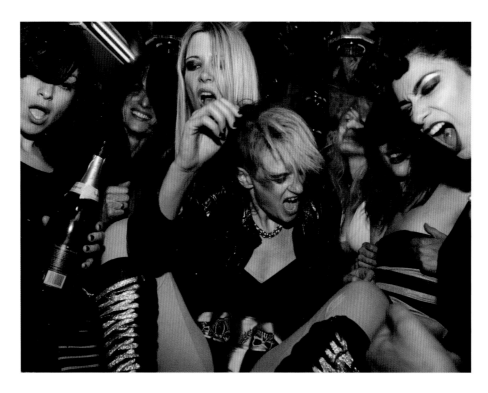

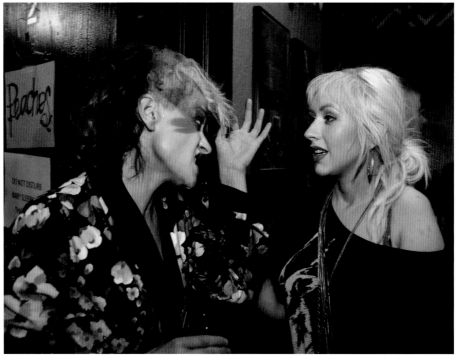

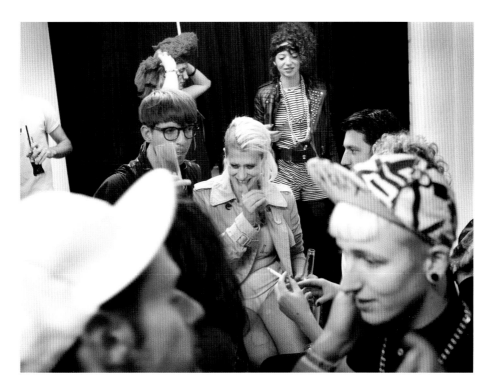

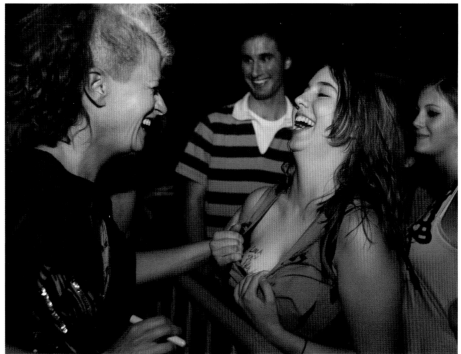

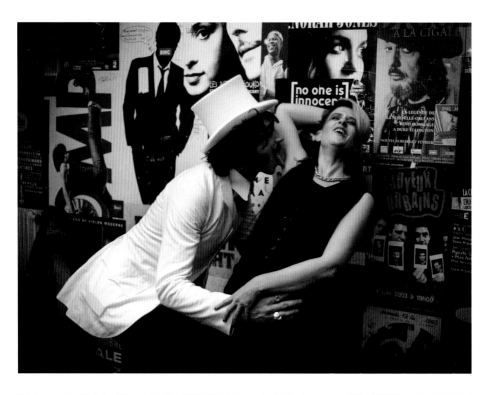

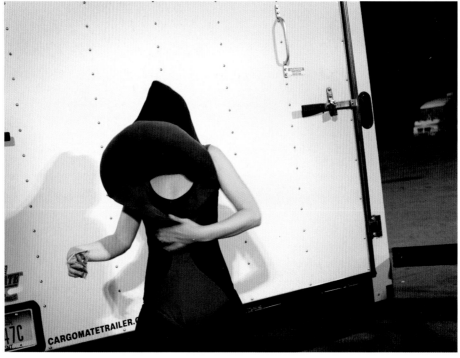

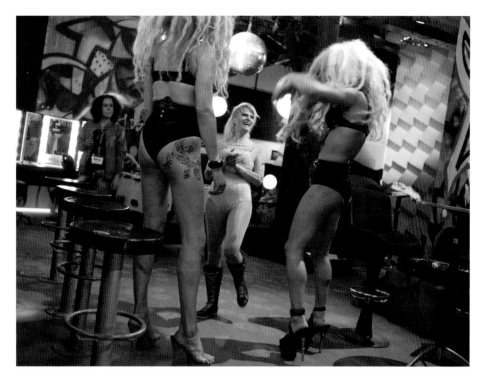

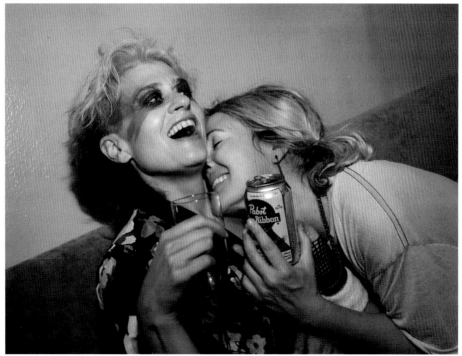

SHE OFFERED SOMETHING THAT I COULD NOT FIND ELSEWHERE

ELLEN PAGE

I was sixteen when I went to my first Peaches show. I had moved from Halifax, Nova Scotia, where very few major musicians pass through, to Toronto, and the opportunity to see someone who I adored was thrilling. My best friend and I arrived at the Opera House earlier than I have ever shown up for anything. We were going to have our bodies pressed up against that stage, we were going to dance, we were going to get fucking sweaty, and we were going to love it. I remember vividly when the Stranglers' song "Peaches" came on—*"Walking on the beaches, looking at the peaches"*—signaling that she was about to start. The song, which is only slightly over four minutes, felt like it would never end. Then Peaches came out and I watched what is still to this day one of the best shows I have ever seen. If you have not seen P live, may I express with all of myself that you must. She is ferocious, relentless, sexy, confident, and gives all of herself to her audience.

Now, there is something specific that happened that evening and I want to tell you about it (I have not even told Peaches this story). At a certain point during this concert, P grew very concerned. Her face narrowed, looking as if she was going to lose her balance; she leaned forward, putting her hands on her knees, and attempted to compose herself. *Oh no, she's sick*, I thought to myself. Sure enough, she began to dry-heave—suddenly the music had stopped and this poor woman was about to throw up all over the stage. Then she began to vomit, but it was blood that she was spewing all over the audience. The music came back on, everyone was screaming; I had fake blood all over me and my hands in the air, and Peaches grabbed me and ran her hand from my elbow to my wrist, smearing the red liquid along my entire arm.

When the night ended, my friend and I were charged. We did not get on the streetcar and instead walked along Queen Street, adrenaline pumping. We looked at the "blood" all over my arm. We had this artifact. The show was still with us, *she* was still with us, and I didn't want to lose that. So I proceeded to do what I could to keep the mark. I would shower with my arm sticking out from the side of the curtain. I am not really sure how long I kept this up for. Not as long as I wish I'd had to really land this story, but definitely for at least a week or two.

Let me stress that I have no other story even remotely like this and feel slightly horrified writing about myself, but I really want to get across my unwavering admiration for this person. Peaches has, without doubt, been one of the most important musicians in my life. She is more than a musician, though: she is a true artist, and a prolific one at that. For a sixteen-year-old gay person, she offered something that I could not find elsewhere. A voice that said, *Fuck shame, fuck the male-dominated perspectives of sex, fuck gender stereotypes, fuck not embracing your desires, and fuck not owning yourself.*

Peaches is radically herself in a way that not many people are. Despite being unapologetically sexual, bold, and aggressive, she instills her work with moments of beautiful vulnerability. There is a moment very close to the end of her film *Peaches Does Herself* where the camera stays on her while she sings, *"I don't want to lose you,"* and this one shot cuts through all of the theatrics and sexual imagery you've just seen and hits the heart hard. How does she do it? I am not sure. I will say that she is one of the most sincere human beings I know, so present, curious, thoughtful, and kind. Perhaps that is the trick. Existing in the world in such a true and honest way leads to work of such integrity.

I guess this is turning into a sort of love letter to Peaches, which is strange because she is a friend, but perhaps this is the only way to tell her just how much of an impact she's had on me and how thankful I am to her and for her. I know there are countless others who feel this way too. Peaches is a person who inspires. A kind of true inspiration that is so very rare. Just like Peaches herself.

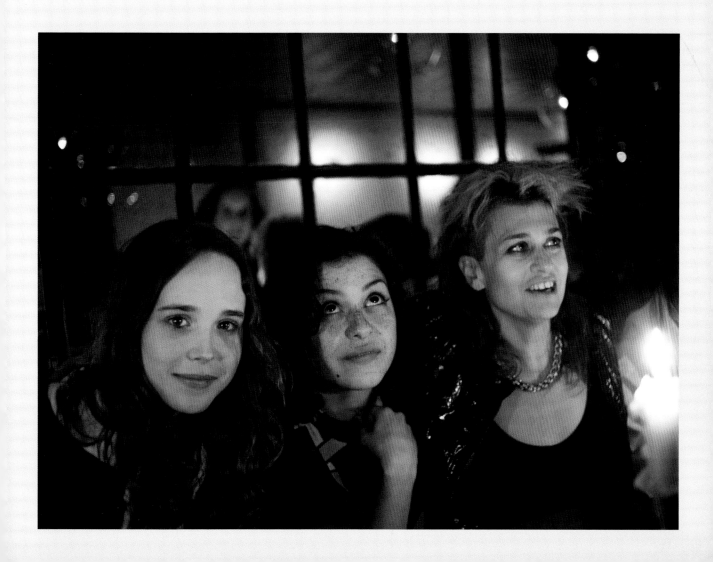

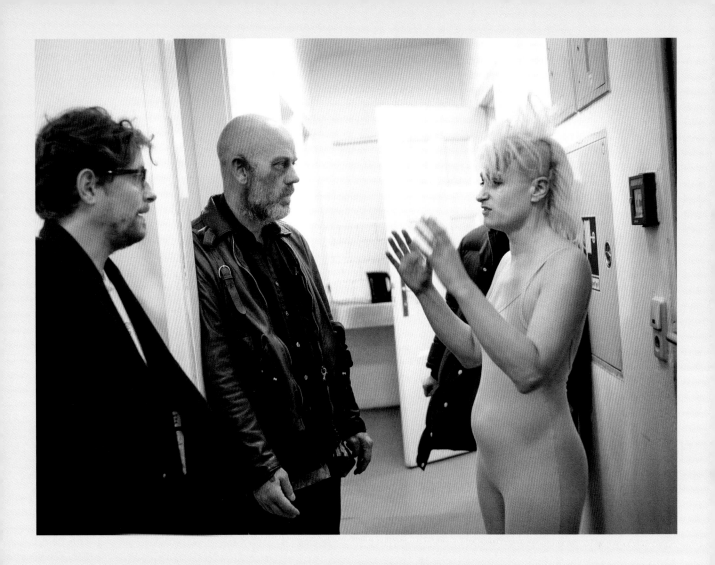

I WAS PRETTY SURE SHE DIDN'T SPEAK FOR ME. BOY WAS I WRONG.

MICHAEL STIPE

i had heard about this peaches. i was afraid i didn't know what to expect, but i was pretty sure she didn't speak for me. boy was i wrong.

i heard the song and i laughed, and i wondered why no one had done this before. it was absolute genius. i had not felt this way in a very long time—i felt the same as when i first heard the sex pistols, the stranglers, david bowie, public enemy, missy elliott. here was something new and absolutely right now.

in the thirteen years that i have closely followed peaches's moves and her career, here is what i have garnered:

she's fearless, *yes*.
she's iconoclastic, *check*.
she is genre-busting, *check*.
she's audacious and offensive, *check*.
she is hysterical, brilliant, tuneful, *check*.
epiphanic, *check*.
revolutionary, *check*.
disturbing, sexy, completely self-effacing, *check*.
she's vulnerable, *oh yeah, now, now*.

yeah, yeah, hang on.

this, right here, is her strength—as an artist, as a performer, as a no, you-come-to-me . . . you-know-you-want-to fringe icon. peaches defines her time here in the twenty-first century. she will speak for any and all of us if we will not speak for ourselves. she is brave enough to be completely current, human, vulnerable.

this alone is courageous and brilliant. peaches allows her vulnerability to be shared, to be a huge component of her power. from the yoko *cut piece*, to *peaches christ superstar*, to *peaches does herself*. to the first time we heard that voice. to her foray into mainstream disco, to her most recent, astonishing incarnation.

this is balls like we haven't seen since patti smith; she is die antwoord, kim gordon, nwa. she stands tall and she is fearless. that is my definition of a hero, heroine, progressive, icon—locked in, and ready to rumble.

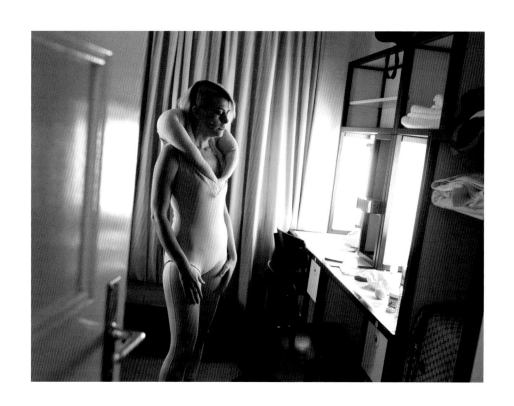

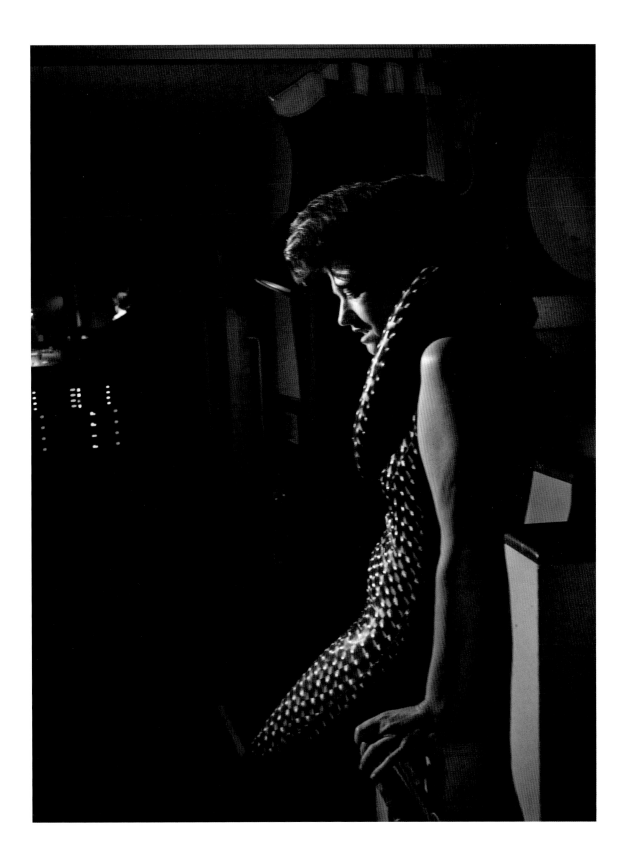

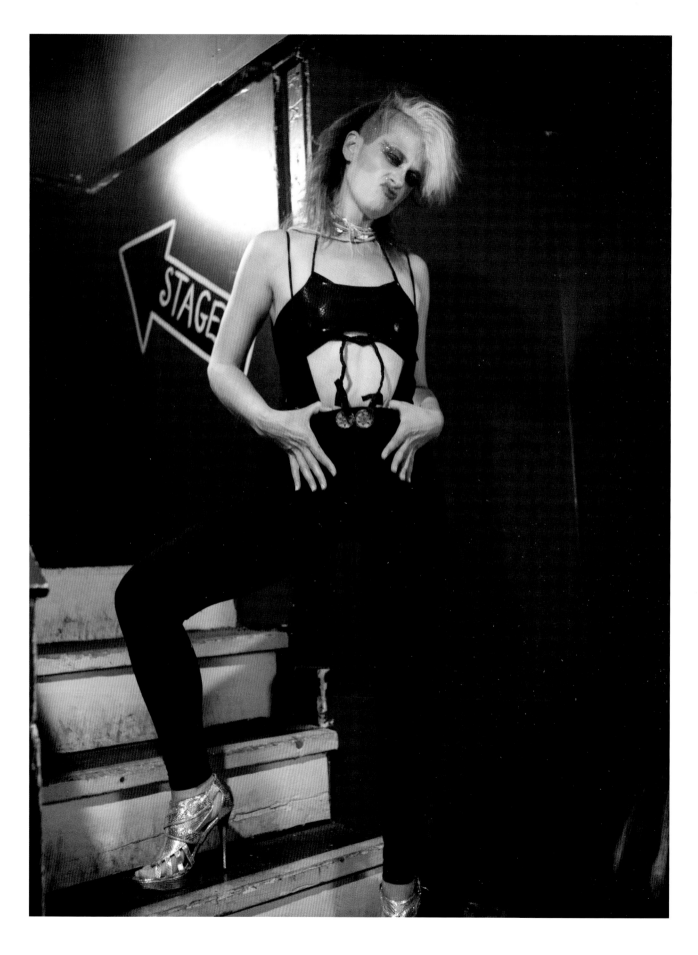

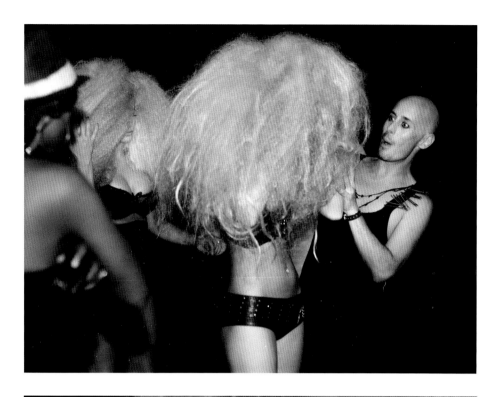

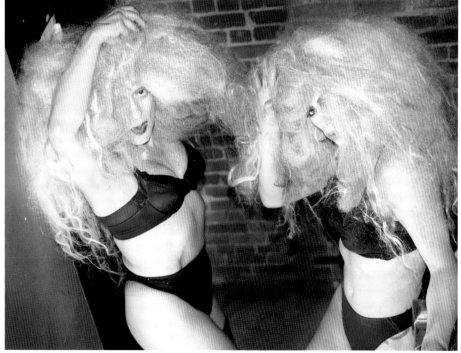

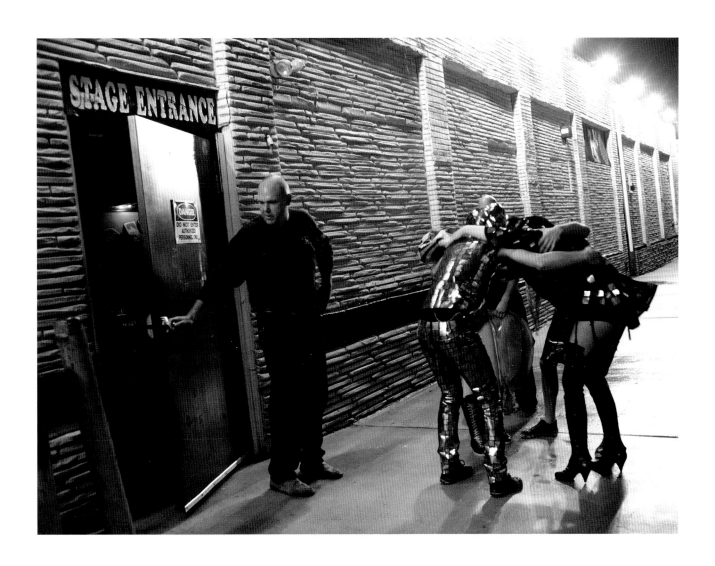

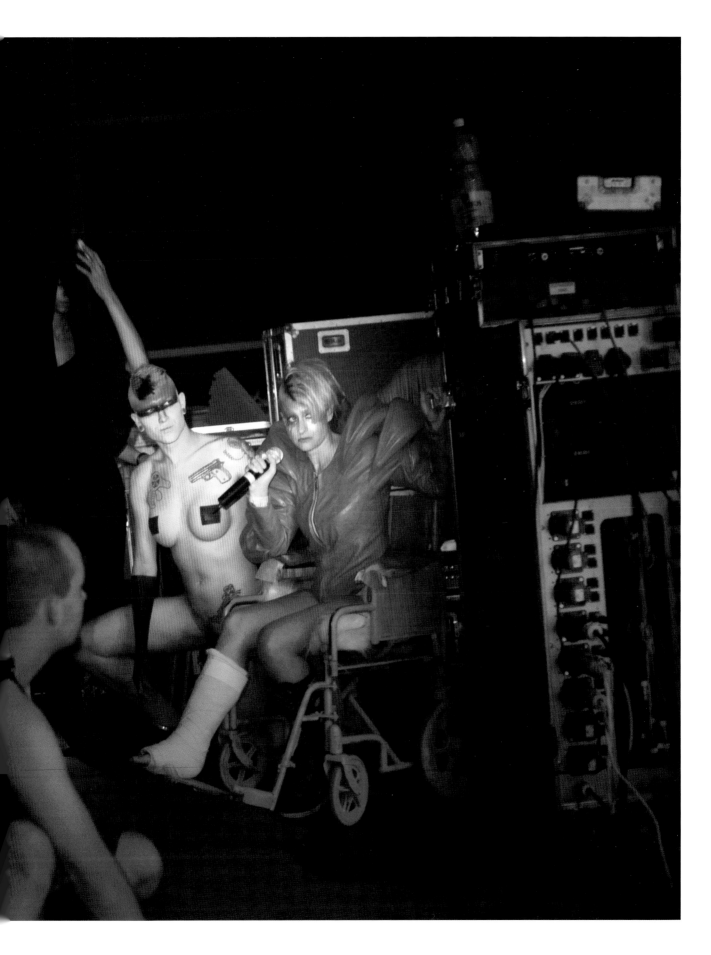

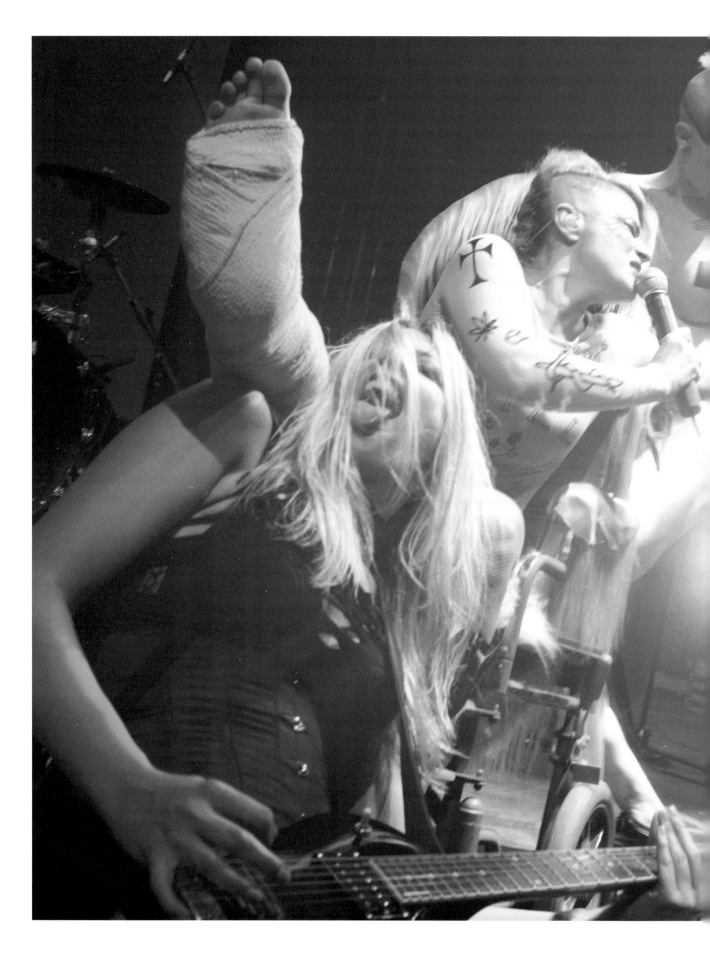

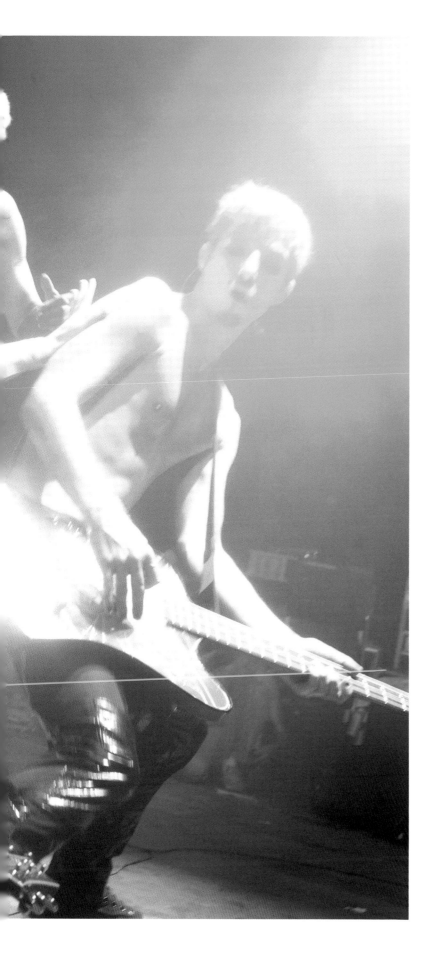

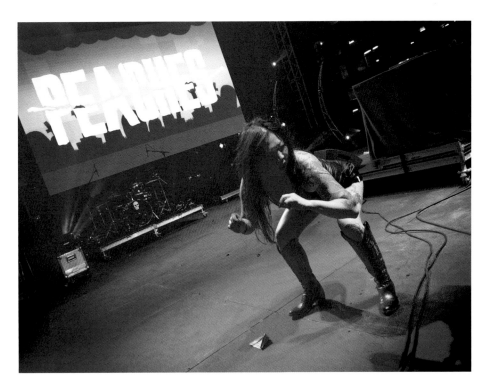

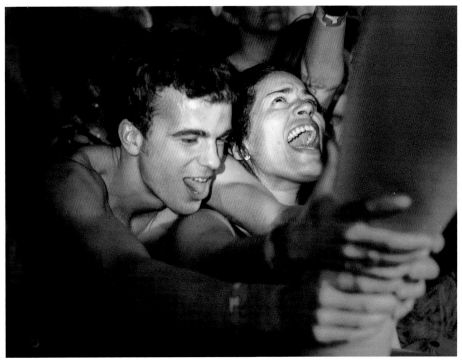

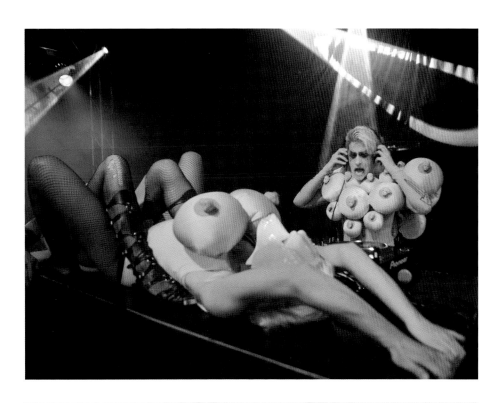

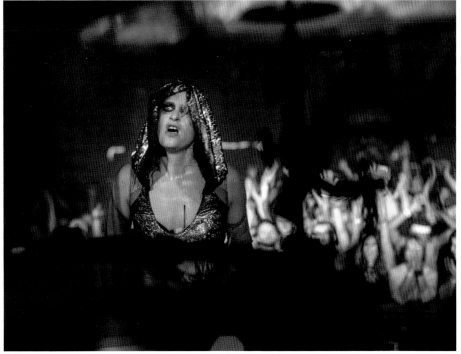

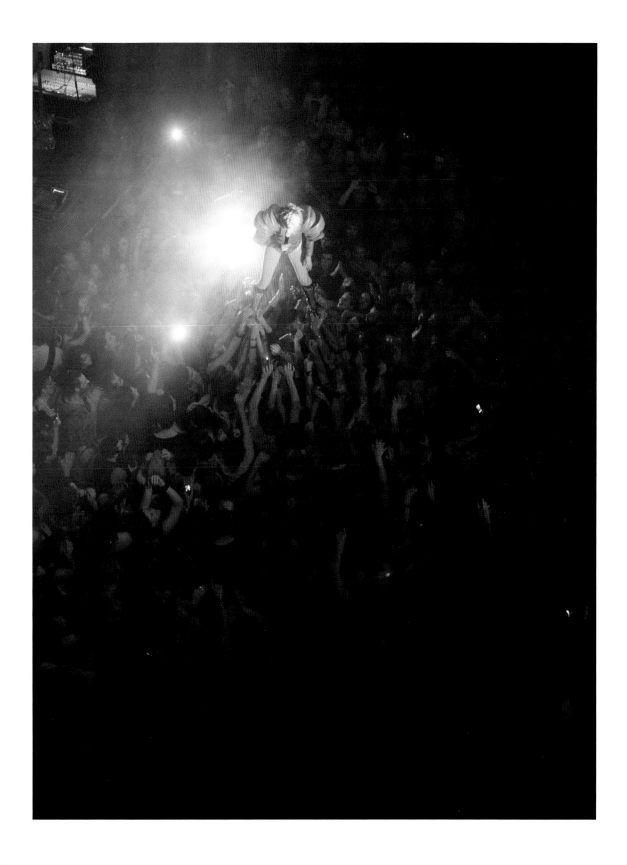

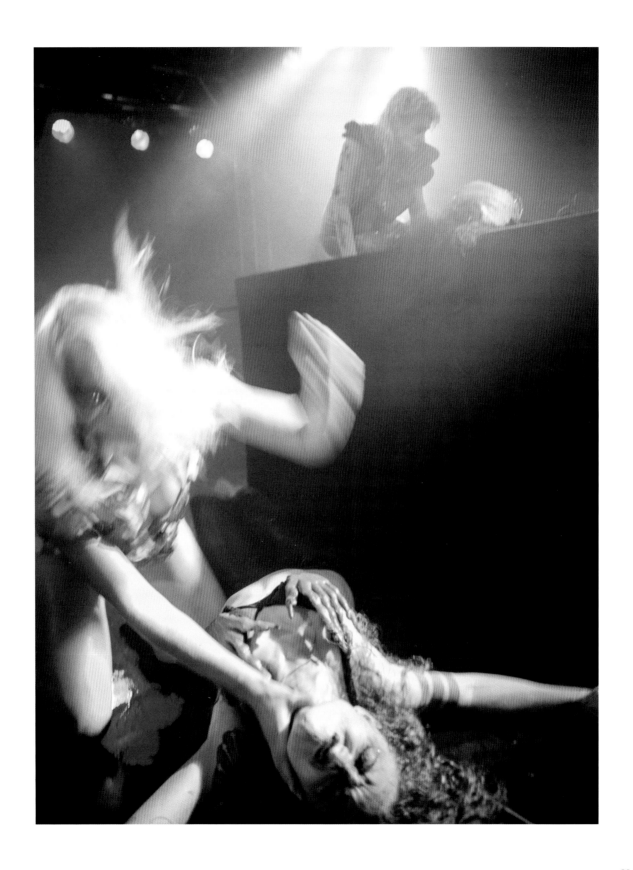

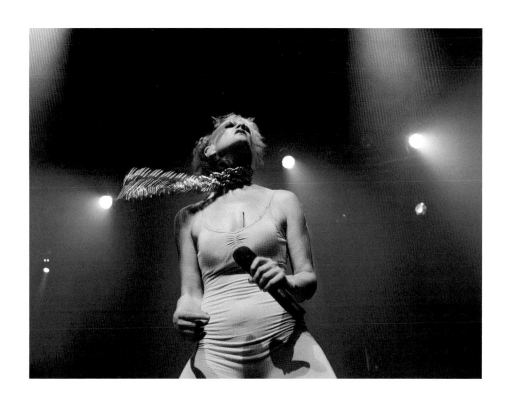

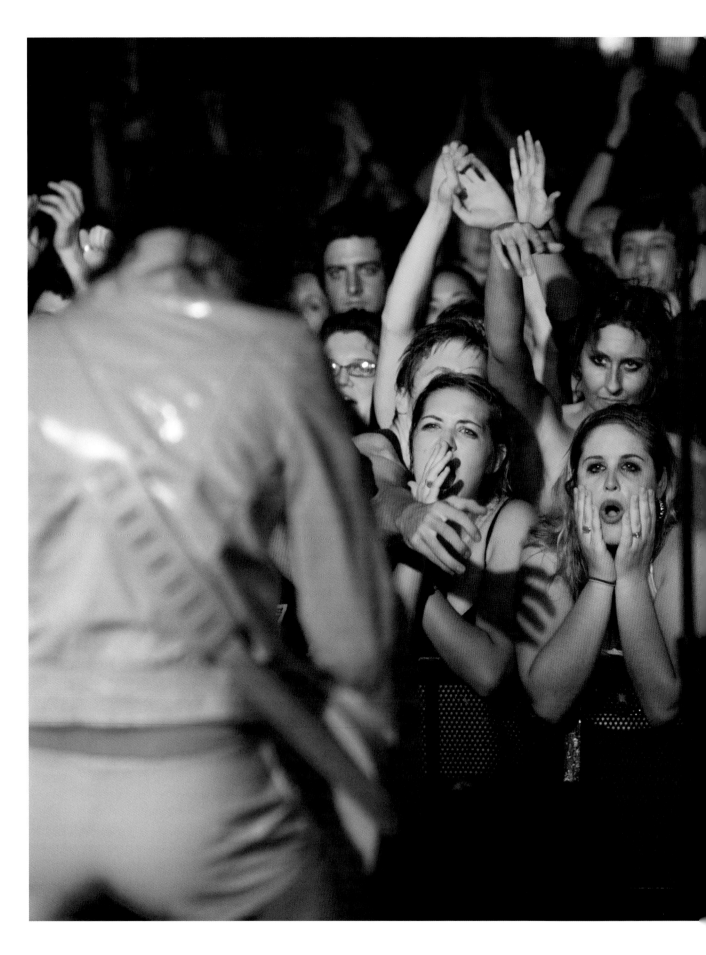

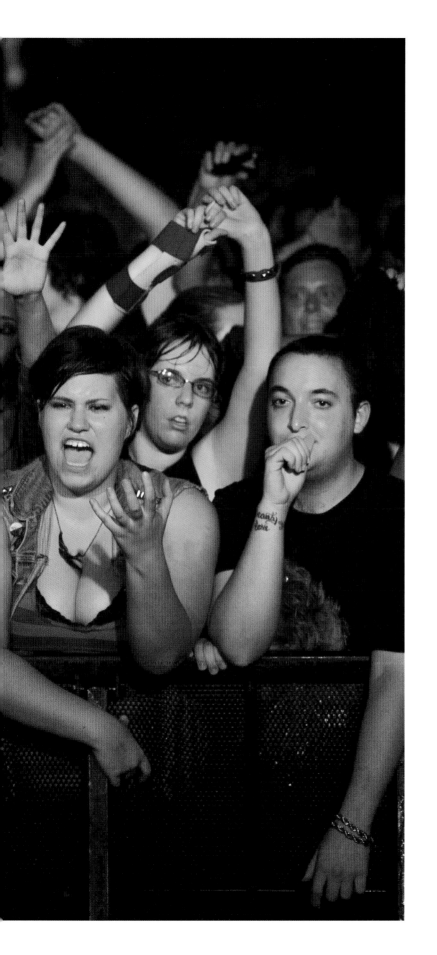

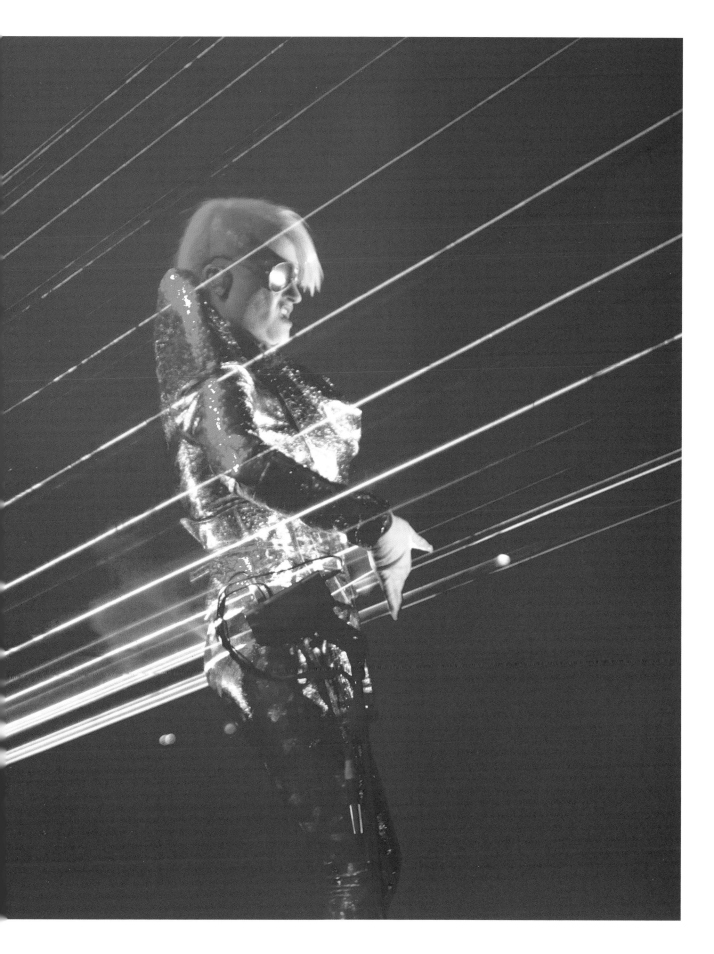

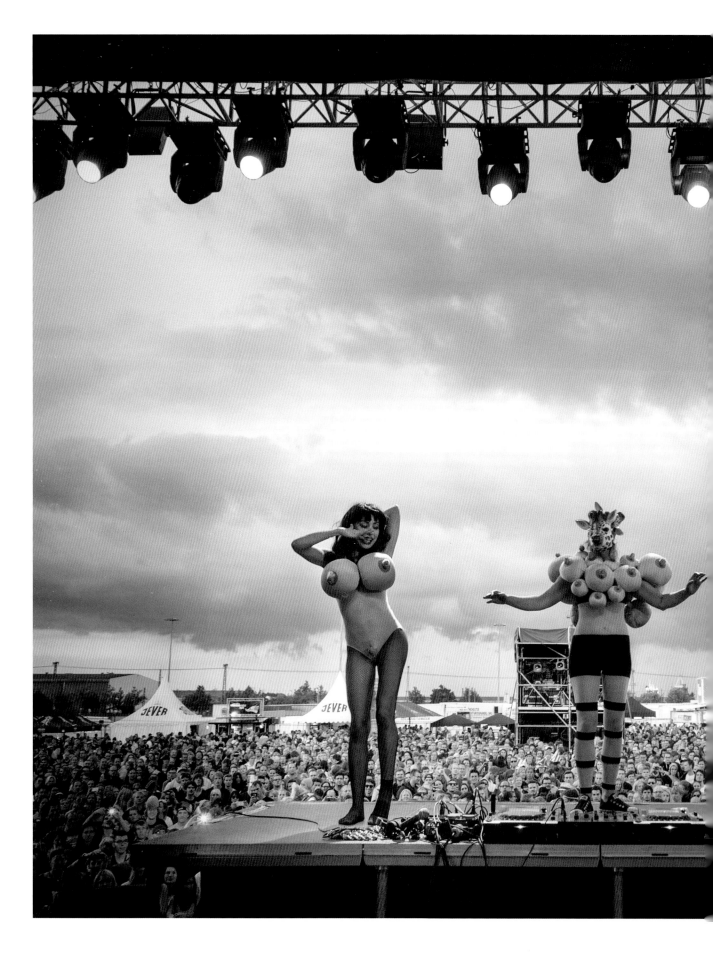

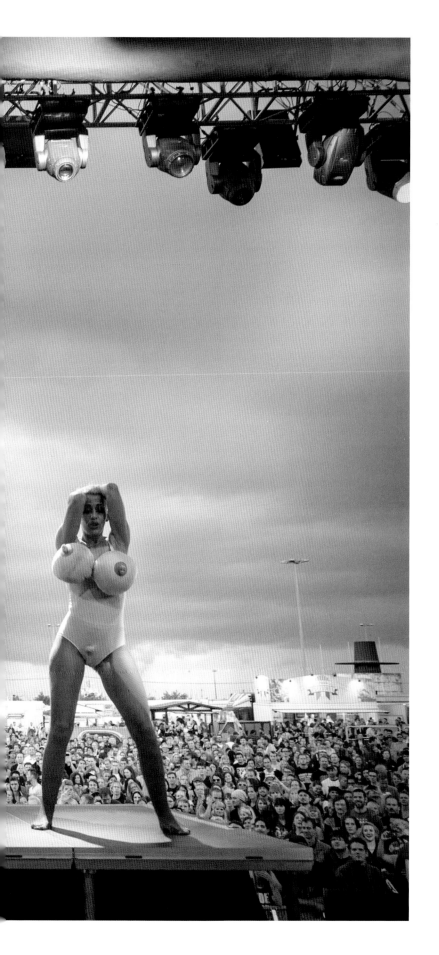

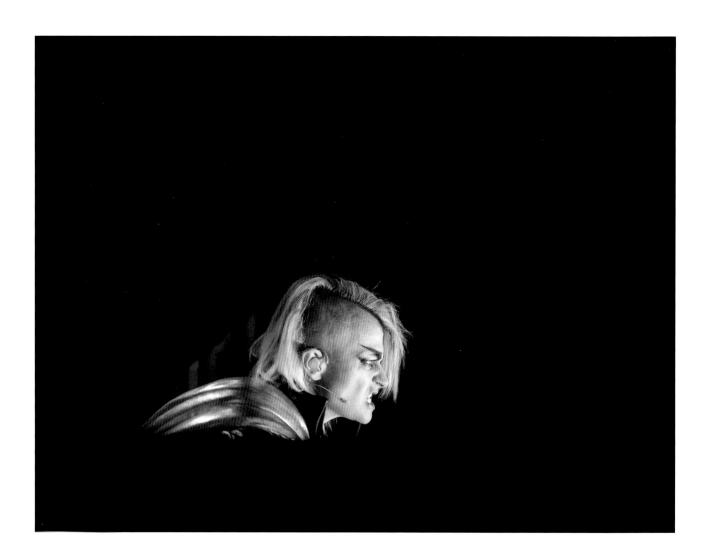

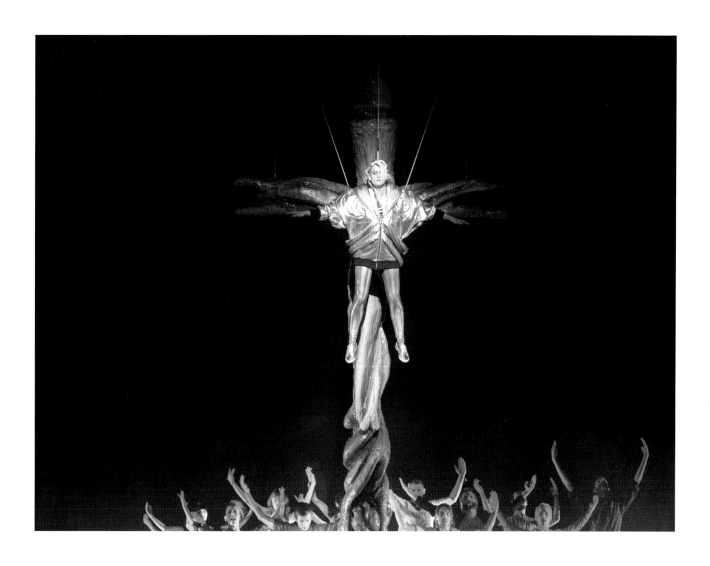

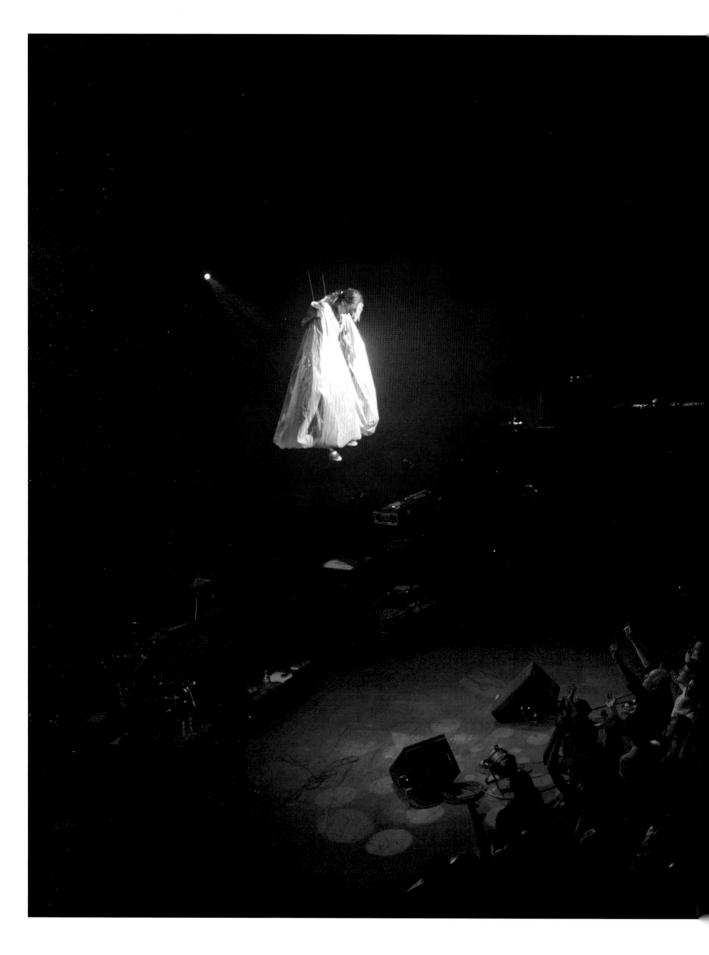

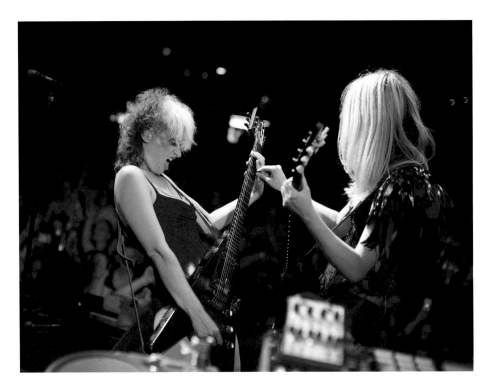

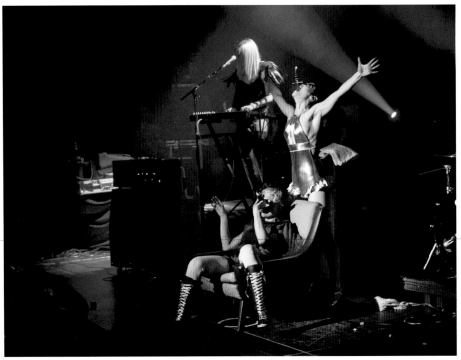

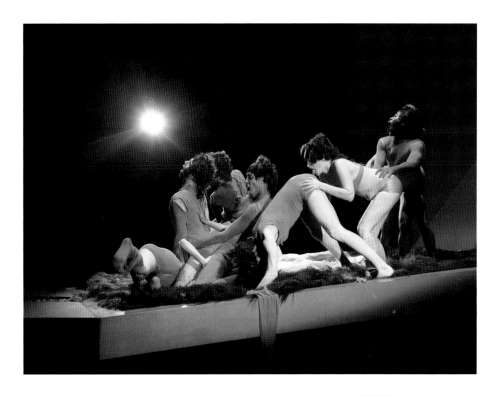

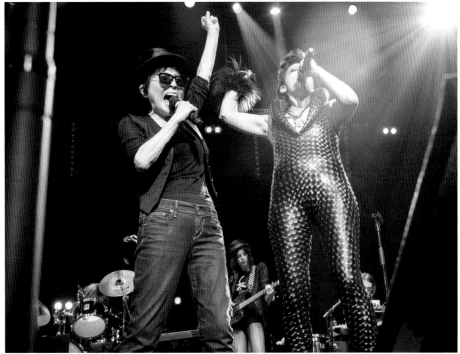

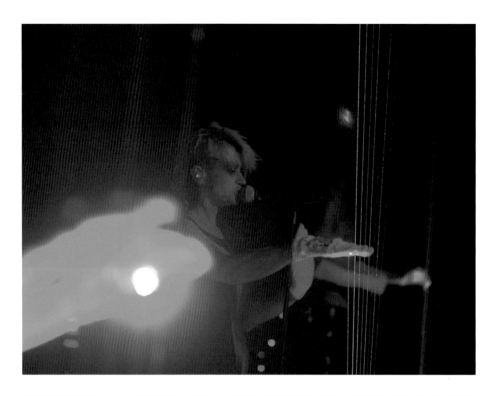

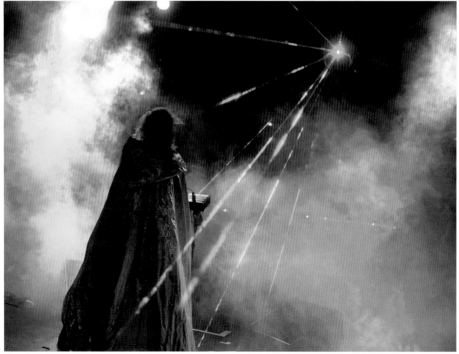

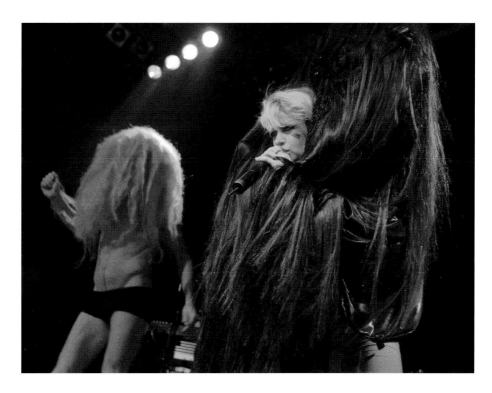

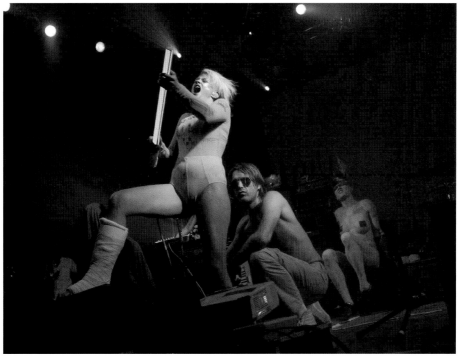

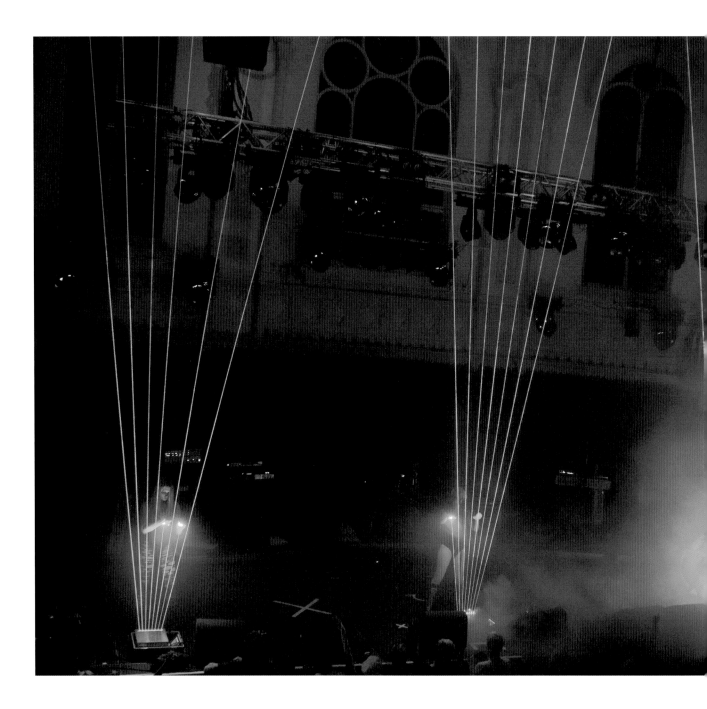

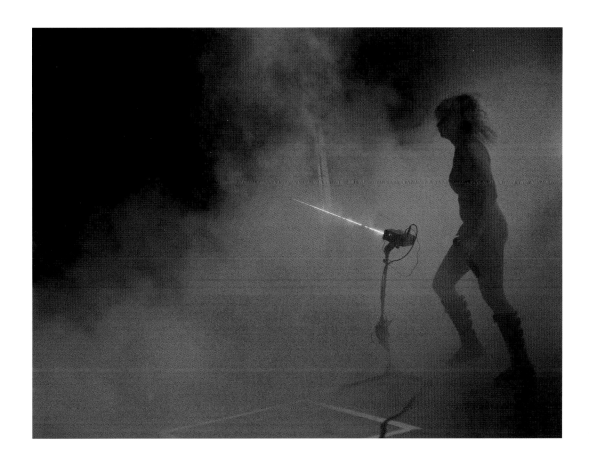

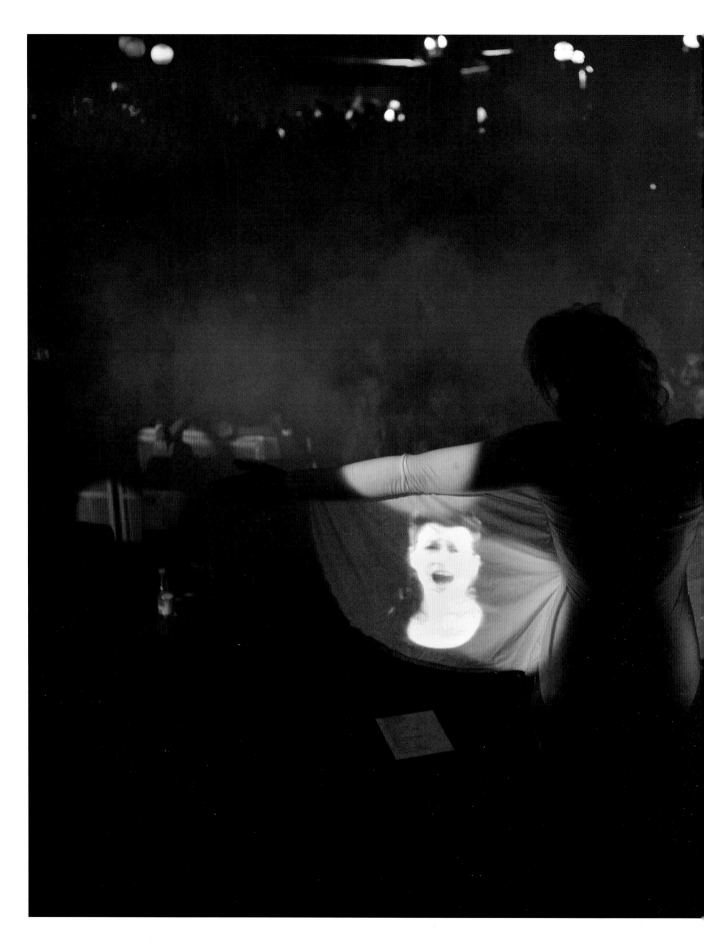

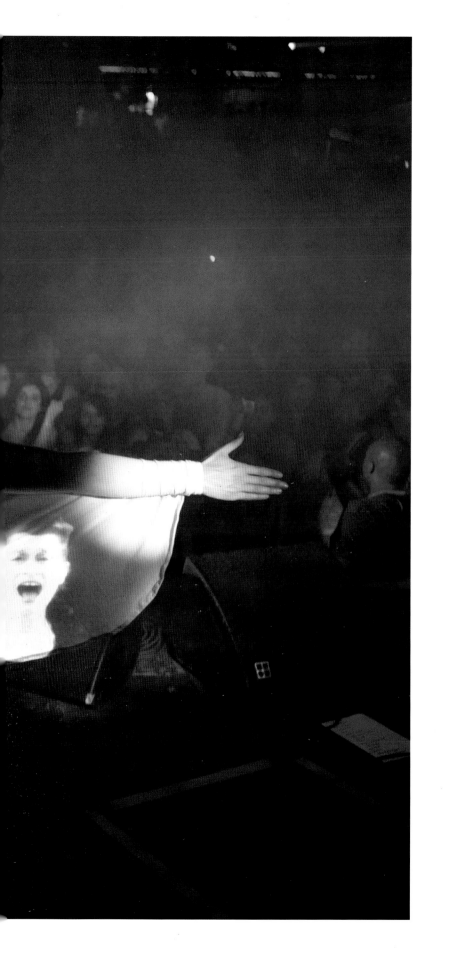

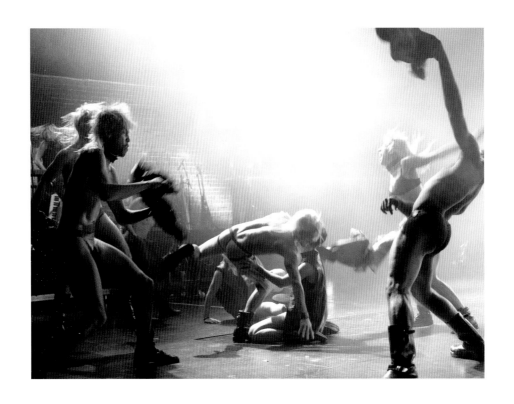

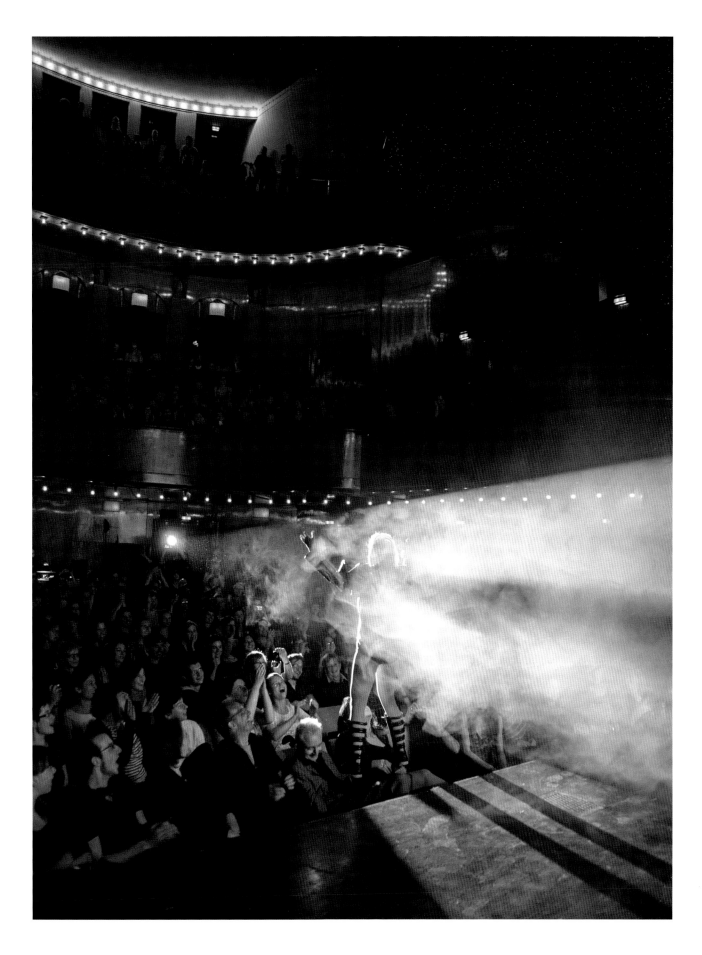

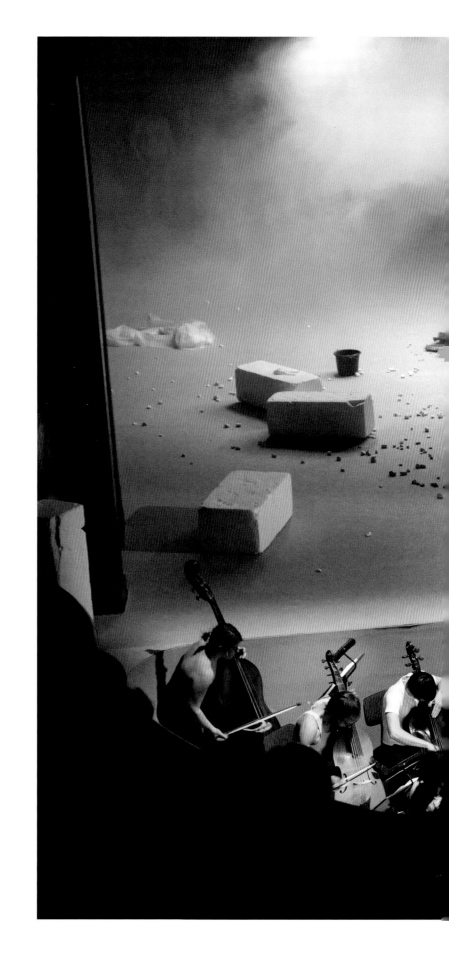

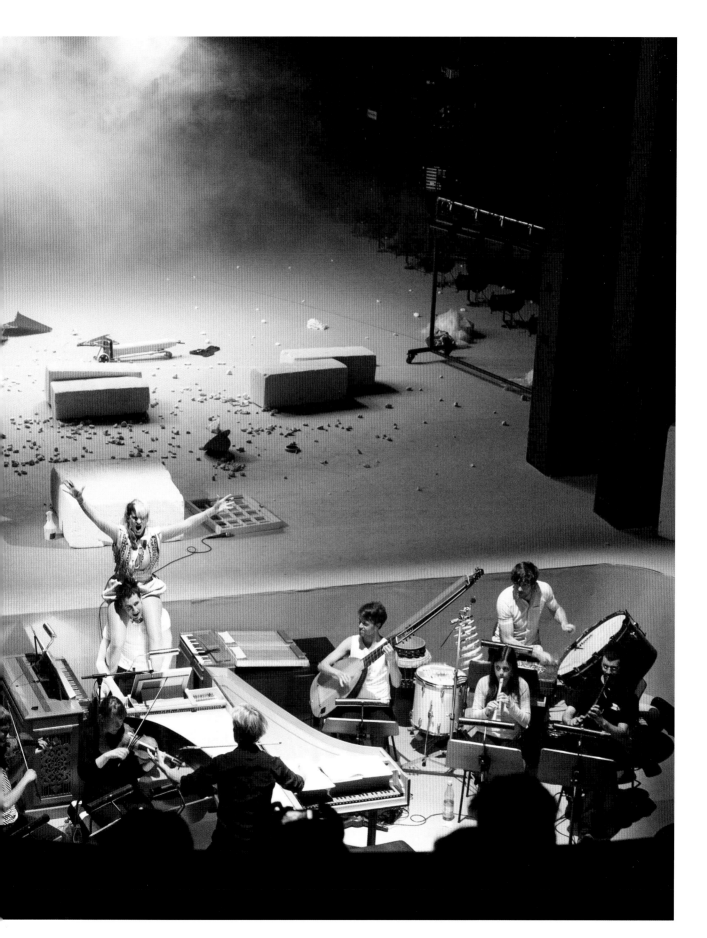

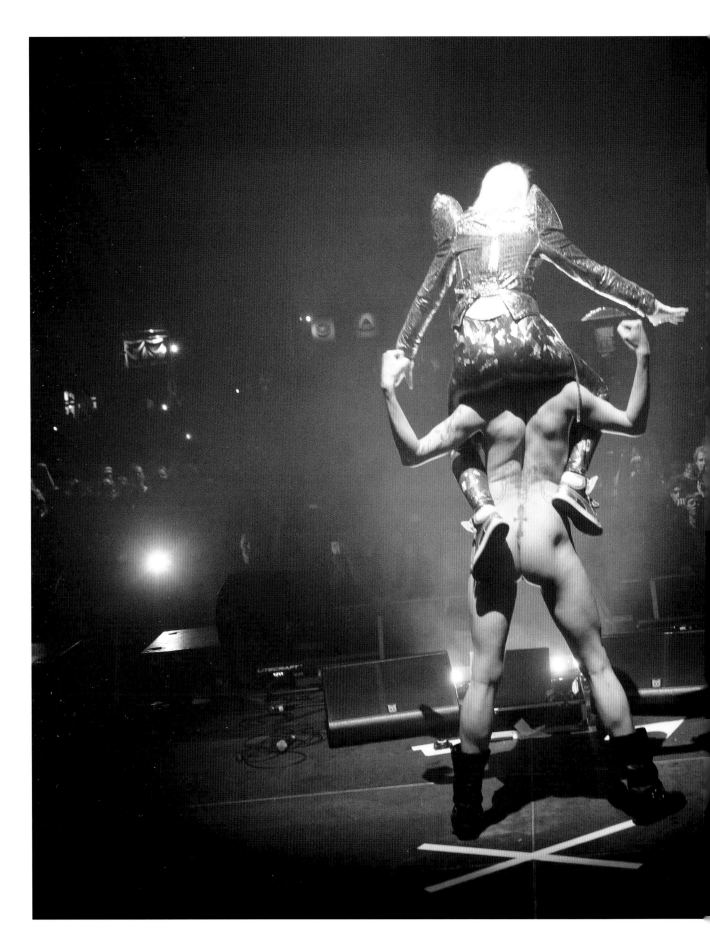

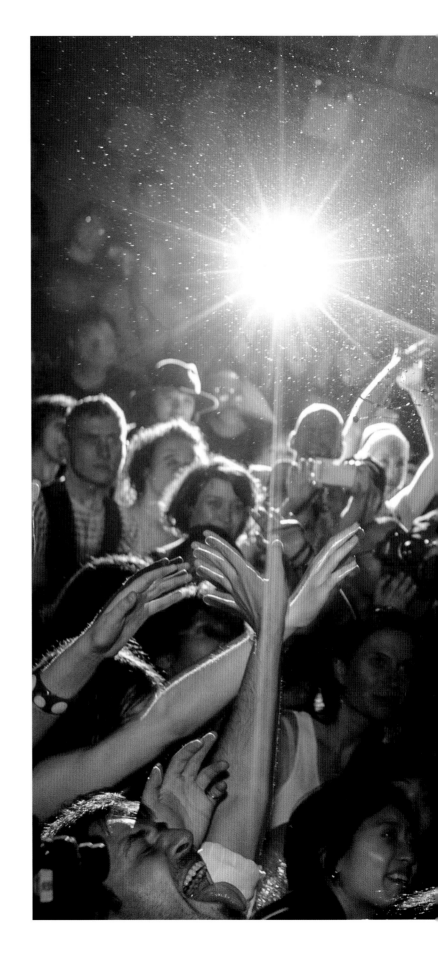

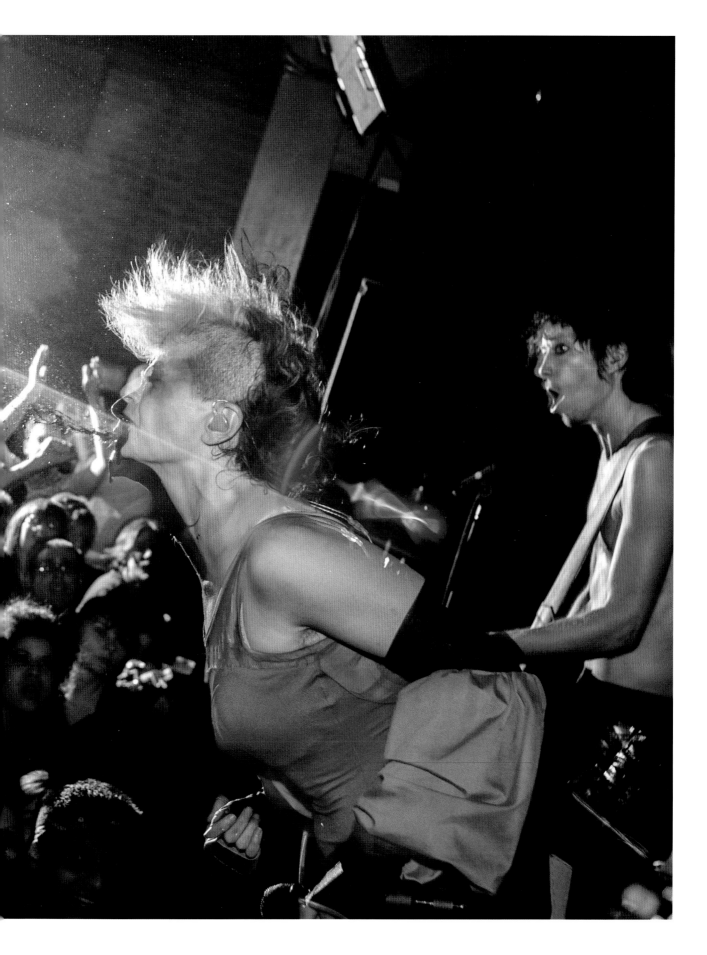

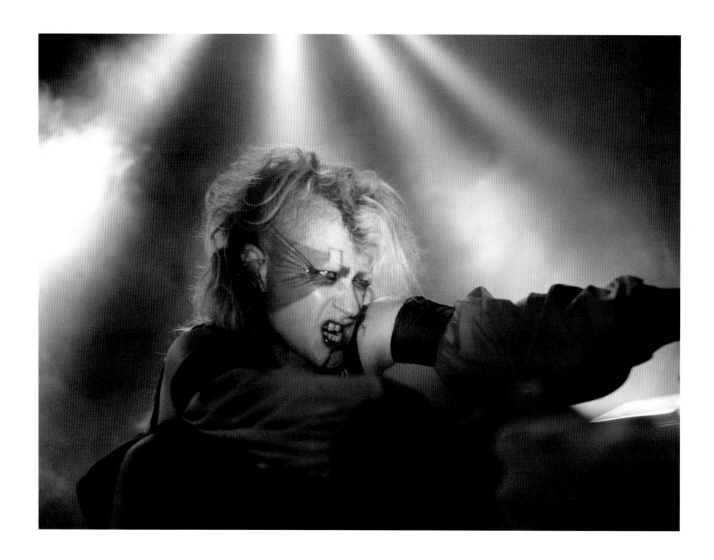

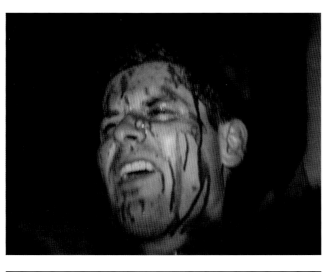
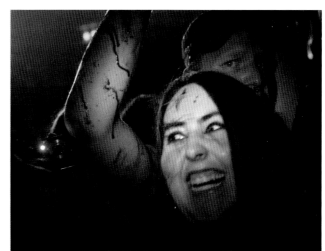

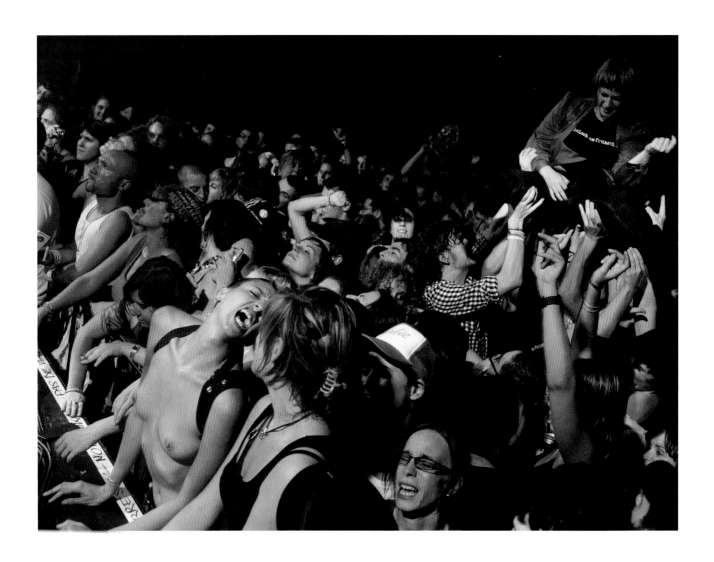

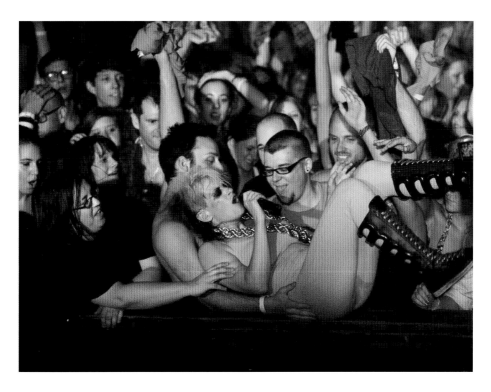

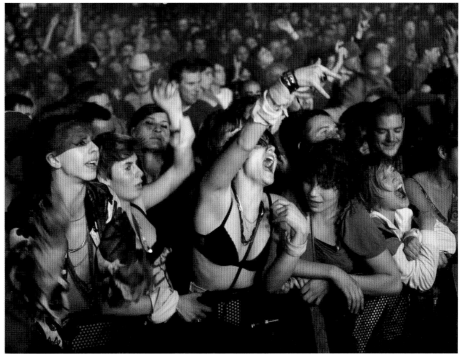

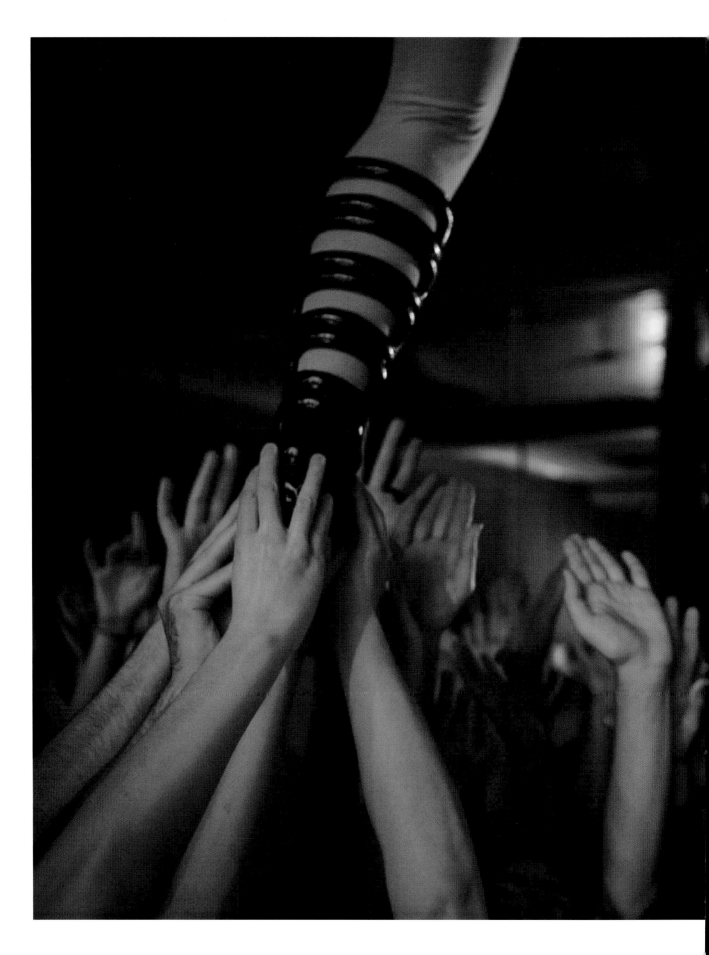

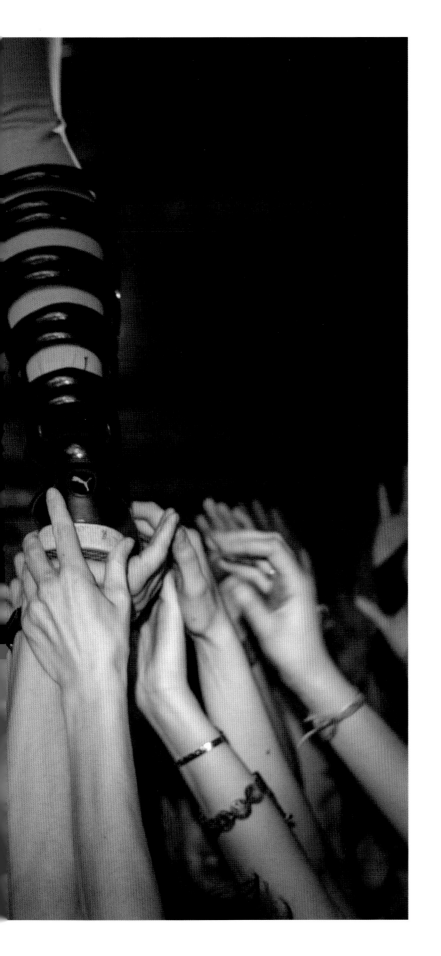

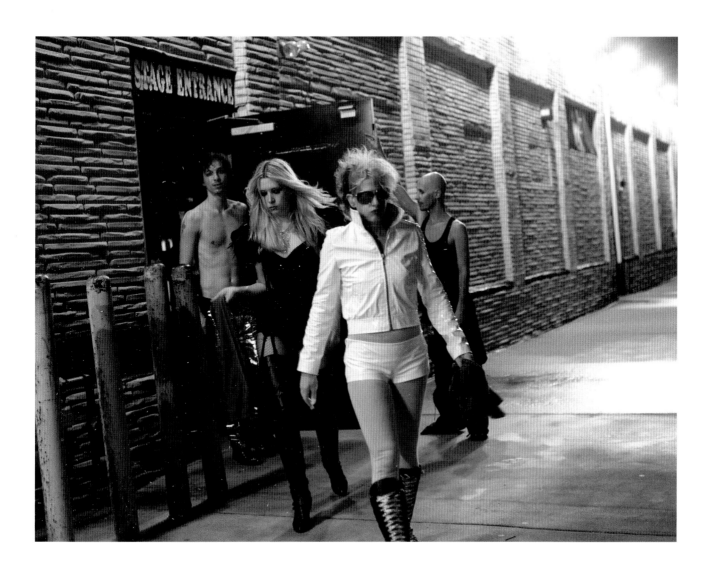

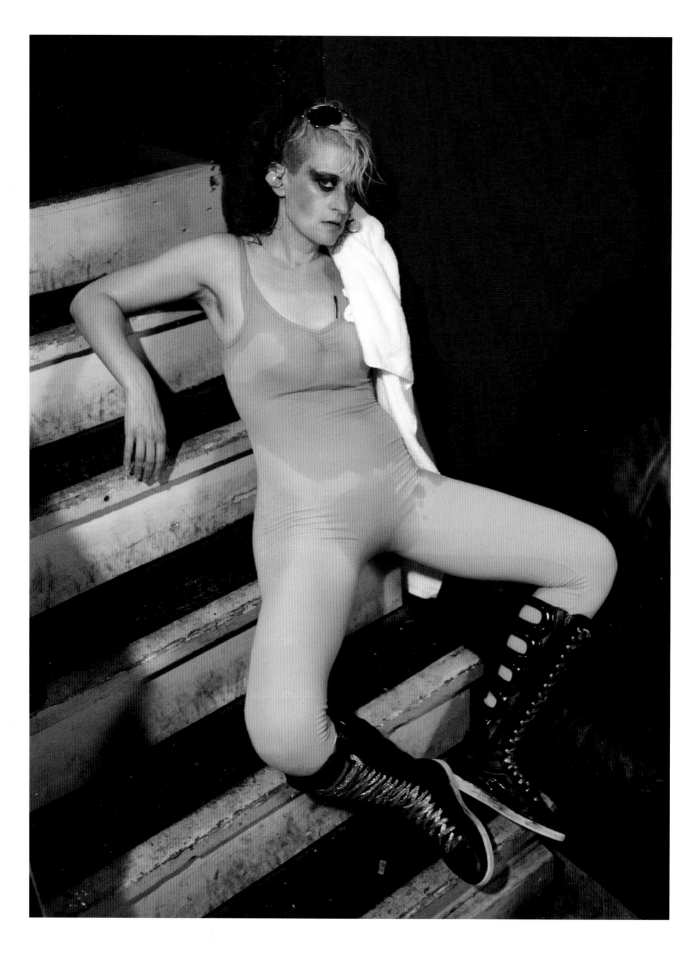

INDEX

57
Viktoria Modesta, Peaches,
Miss Annabel Sings,
Mr Pustra, Titus Groan &
Scottee
Royal Festival Hall
London, UK
April 2009

58
John Renaud & Peaches
Portland Open Air
Hamburg, Germany
August 25, 2012

59
Sandy Kane, Danni
Daniels, Saskia Hahn,
Mathias Brendel, Peaches,
Joel Gibb & Conner Rapp
Peaches Does Herself
Rehearsal
Berlin, Germany
October 2010

60
P!nk & Peaches
Festival Supreme
Los Angeles, California
October 25, 2014

61
Magna Carta Celebration
London, UK
June 15, 2013

62
Mignon, Simonne Jones,
Peaches, Danni Daniels &
Saskia Hahn
Feest in het Park
Oudenaarde, Belgium
August 13, 2010

63
Peaches Does Herself
HAU Theater
Berlin, Germany
May 6, 2011

64
Vice Cooler & Peaches
Tour Bus
Los Angeles, California
June 2009

65
The Fonda Theatre
Los Angeles, California
June 6, 2009

67
Yoko Ono & Peaches
Meltdown Festival
London, UK
June 16, 2013

68–71
Cut Piece
Meltdown Festival
London, UK
June 16, 2013

72/73
Grace Jones's
Signature on Cast
Peaches's Home
Berlin, Germany
August 2010

74/75
Peaches &
Suri Nisker (sister)
White Plains, New York
June 2014

76 top
Peaches's Home
Berlin, Germany
April 2009

76 bottom
Peaches &
Cole Yaverbaum (niece)
Larchmont, New York
June 20, 2009

77 top
Peaches's Home
Berlin, Germany
April 2009

77 bottom
Painting by Yoon Lee
Peaches's Home
Berlin, Germany
April 2009

78/79
Bernie and Loreen Nisker
(parents), Peaches &
Jace (nephew)
Larchmont, New York
June 2009

80/81
Studio Charlie Le Mindu
London, UK
April 2009

82
Shanna Nash, Peaches &
John Renaud
Los Angeles, California
October 2014

83
Peaches & JD Samson
Los Angeles, California
June 2009

84
Haus der Kulturen der Welt
Berlin, Germany
August 18, 2011

85
L'Orfeo
HAU Theater
Berlin, Germany
April 29, 2012

86/87
Peaches's Birthday Party
Berlin, Germany
November 11, 2011

89
Peaches, Annie Sprinkle &
Beth Stephens
San Francisco, California
November 2014

90
Tour Bus
London, UK
August 2009

91
Peaches, Simonne Jones,
Demonstrators & Media
Pussy Riot Demonstration
Berlin, Germany
August 2012

92 top
Drums of Death,
Peaches, Charlie Le Mindu &
Jamie Bull
Tour Bus
Brussels, Belgium
May 2009

92 bottom
Saskia Hahn & Peaches
Tour Bus
Amsterdam, Netherlands
May 2009

93 top
Berlin, Germany
May 2009

93 bottom
Vice Cooler,
Peaches & Brendan
Schoenwetter
Tour Bus
London, UK
December 2012

94 top
Sabina Turek, friend, Saskia
Hahn, Peaches, friend,
Alissa Nicolaï & Jewels Good
Tour Bus Party
Berlin, Germany
May 2009

94 bottom
Peaches & Christina Aguilera
The Fonda Theatre
Los Angeles, California
June 6, 2009

95 top
Jackee Word & friends
Berlin, Germany
October 2010

95 bottom
The Masquerade
Atlanta, Georgia
June 15, 2009

96 top
La Cigale
Paris, France
January 23, 2009

96 bottom
Peaches
Dallas, Texas
June 2009

97 top
Patricia Piatke,
Gloria Viagra, Peaches &
Bradley Berlin
Arte Lounge
Berlin, Germany
May 27, 2010

97 bottom
Peaches & Drew Barrymore
The Fonda Theatre
Los Angeles, California
June 6, 2009

99
Ellen Page, Alia Shawkat &
Peaches
Amsterdam, Netherlands
May 2009

100
Thomas Dozol,
Michael Stipe & Peaches
Peaches Does Herself
HAU Theater
Berlin, Germany
October 31, 2010

102
Peaches Christ Superstar
HAU Theater
Berlin, Germany
March 27, 2010

103
Royal Festival Hall
London, UK
June 14, 2013

104
Cat's Cradle
Carrboro, North Carolina
June 16, 2009

105 top
Carmen Electra, friend &
Vaughan Alexander
The Fonda Theatre
Los Angeles, California
June 7, 2009

105 bottom
Joey Arias & Sherry Vine
Music Hall of Williamsburg
Brooklyn, New York
June 19, 2009

107
Peaches & Sweet Machine:
Saskia Hahn, Mathias
Brendel, Conner Rapp &
Vaughan Alexander
Preshow, The Stone Pony
Asbury Park, New Jersey
June 20, 2009

108/109
Cyndy Villano, Tranimal
Dancers, Simonne Jones,
Danni Daniels & Peaches
Sziget Festival
Budapest, Hungary
August 11, 2010

110/111
Saskia Hahn, Peaches,
Danni Daniels &
Conner Rapp
Sziget Festival
Budapest, Hungary
August 11, 2010

112 top
Margaret Cho
Festival Supreme
Los Angeles, California
October 25, 2014

112 bottom
Music Hall of Williamsburg
Brooklyn, New York
June 19, 2009

113 top
Ginger Synne,
Frau Pepper & Peaches
Haus der Kulturen der Welt
Berlin, Germany
August 18, 2011

113 bottom
The Masquerade
Atlanta, Georgia
June 15, 2009

115
Paradiso
Amsterdam, Netherlands
December 10, 2009

116
Frau Pepper, Ginger Synne &
Peaches
Haus der Kulturen der Welt
Berlin, Germany
August 18, 2011

117
The Fonda Theatre
Los Angeles, California
June 6, 2009

118/119
Cat's Cradle
Carrboro, North Carolina
June 16, 2009

120/121
Berlin Festival
Berlin, Germany
September 11, 2010

122/123
Louise de Ville,
Peaches & Frau Pepper
Portland Open Air
Hamburg, Germany
August 25, 2012

124
Peaches Christ Superstar
HAU Theater
Berlin, Germany
June 1, 2010

125
Peaches Christ Superstar
HAU Theater
Berlin, Germany
March 25, 2010

126/127
Royal Festival Hall
London, UK
April 10, 2009

128/129
The Fonda Theatre
Los Angeles, California
June 6, 2009

130 top
Peaches & Saskia Hahn
Dallas, Texas
June 12, 2009

130 bottom
Peaches & Jewels Good
Melkweg
Amsterdam, Netherlands
May 8, 2009

131 top
Peaches &
The Fatherfucker Dancers:
Marcela Donato,
Muck Muñoz,
Assaf Hochman, Emi Sri,
Justin Francis Kennedy,
Lia Dimou, Quincy Junor, &
Fernando Belfiore
Peaches Does Herself
HAU Theater
Berlin, Germany
May 4, 2011

131 bottom
Plastic Ono Band & Peaches
Meltdown Festival
London, UK
June 14, 2013

132 top
Paard van Troje
Den Haag, Netherlands
December 12, 2009

132 bottom
Le Bataclan
Paris, France
December 11, 2009

133 top
Tranimal Dancers & Peaches
Bürgerhaus Stollwerck
Cologne, Germany
December 15, 2009

133 bottom
Peaches, Frank Itty &
Danni Daniels
Sziget Festival
Budapest, Hungary
August 11, 2010

134
Saskia Hahn, Peaches &
Conner Rapp
Paradiso
Amsterdam, Netherlands
December 10, 2009

135
Magnolia Parade Festival
Milan, Italy
September 3, 2009

136/137
Magnolia Parade Festival
Milan, Italy
September 3, 2009

138
The Fatherfucker Dancers
Peaches Does Herself
HAU Theater
Berlin, Germany
October 23, 2010

139
Peaches Does Herself
HAU Theater
Berlin, Germany
May 6, 2011

140 / 141
Solistenensemble
Kaleidoskop & Peaches
L'Orfeo
HAU Theater
Berlin, Germany
April 29, 2012

142 / 143
Peaches & Danni Daniels
Berlin Festival
Berlin, Germany
September 11, 2010

144 / 145
Music Hall of Williamsburg
Brooklyn, New York
June 19, 2009

146
Bürgerhaus Stollwerck
Cologne, Germany
December 15, 2009

147 top left
The Stone Pony
Asbury Park, New Jersey
June 20, 2009

147 top right
KOKO
London, UK
December 13, 2009

147 bottom left
Bürgerhaus Stollwerck
Cologne, Germany
December 15, 2009

147 bottom right
9:30 Club
Washington, DC
June 17, 2009

148
Le Zoo
Geneva, Switzerland
October 8, 2009

149 top
The Masquerade
Atlanta, Georgia
June 15, 2009

149 bottom
Festival Woodstower
Lyon, France
August 29, 2009

150 / 151
Astra Kulturhaus
Berlin, Germany
December 16, 2009

153
Conner Rapp, Saskia Hahn,
Peaches & Vaughan Alexander
The Stone Pony
Asbury Park, New Jersey
June 20, 2009

154
Cat's Cradle
Carrboro, North Carolina
June 16, 2009

PEACHES,

born Merrill Nisker in Toronto, is a musician, singer,
performance artist, producer, filmmaker, actor, and writer,
who has lived and worked in Berlin since 2000.
She has released four albums — *The Teaches of Peaches*,
Fatherfucker, *Impeach My Bush*, and *I Feel Cream* — and
a new album is forthcoming. She has collaborated and
appeared as a guest vocalist on albums by P!nk, R.E.M., Iggy
Pop, Major Lazer, and Christina Aguilera, to mention a few.
Her songs have been featured in dozens of films and TV shows
including *Mean Girls*, *Lost in Translation*, *Whip It*,
30 Rock, *Ugly Betty*, *South Park*, and *True Blood*. Peaches
has performed in more than fifty countries and
has constantly toured the world for the past fourteen years.
She created *Peaches Christ Superstar*, where she
performed the entire rock opera *Jesus Christ Superstar* as
a one-woman show; and she sang the lead role of L'Orfeo
in a production of Monteverdi's seventeenth-century Italian
opera. Peaches's most ambitious work to date was the
mythical autobiographical electrorock stage-show-turned-
film called *Peaches Does Herself.* The feature film
debuted at the 2012 Toronto Film Festival and was warmly
received at over seventy film festivals around the world.

HOLGER TALINSKI

is a Berlin-based photographer focusing on portrait and
documentary photography. He is also passionate
about skateboarding, which was the reason he started taking
photos in the first place — to document his and his friends'
lifestyle. He studied photography in Bielefeld, Germany, and
interned in New York with Benedict J. Fernandez,
most well-known for photographing Martin Luther King Jr.
Holger's work has also been commissioned in Europe,
the United States, Thailand, and India. For more information,
visit www.holgertalinski.de.